PHOTOGRAPHER'S
TROUBLE SHOOTER

PHOTOGRAPHER'S
TROUBLE
SHOOTER

HOW TO TURN PHOTOGRAPHIC PROBLEMS INTO GOOD PICTURES

MICHAEL FREEMAN

**FREUNDLICH
BOOKS**

A QUILL BOOK

This book was designed and produced by
Quill Publishing Limited
32 Kingly Court
London W1

Art director Nigel Osborne
Editorial director Jeremey Harwood
Senior editor Liz Wilhide
Editor Joanna Rait
Designers Paul Cooper Helen Smith
Steve Wilson
Illustrator Raymond Brown

All photographs by Michael Freeman, except
where individually credited

Filmset by QV Typesetting Limited, London
Origination by Hong Kong Graphic Arts
Service Centre Limited,
Hong Kong
Printed by Leefung-Asco Printers Limited,
Hong Kong

Quill would like to extend special thanks to
Neyla Freeman; Locations Unlimited; Richard
Paterson and John Slater at Nikon UK Ltd; and
Time-Life Books.

ISBN 0-88191-035-X

CONTENTS

INTRODUCTION

In most practical books and magazines on photography, the sun always shines - not only in the style of the pictures, but in the general tone of advice. In a determinedly optimistic style, such writing sets out to convince the reader that taking great pictures is intrinsically easy, glossing over the difficulties and uncertainties that will inevitably occur.

In a way this approach is understandable as an attempt to generate enthusiasm, rather than discourage photographers at the outset. Nevertheless, it seems to me a pity to set out to simplify photography to the point where all the fascinating challenges, both technical and creative, have been side-stepped. The whole process of creating images is full of problems, but it is these very difficulties that can make it so interesting. For anyone who has mastered the use of a camera, snapshots of ordinary subjects under average conditions offer few challenges and little excitement. Photography at any advanced level *is* basically problem-solving.

This is the idea behind this rather different photographic book. There are no ordinary, run-of-the-mill situations here, only selected hurdles and concise ways of tackling them. In some instances, the answer is simple and technical, in others the key is a more radical creative approach. Whenever possible, if you are faced with a problem, instead of first thinking how you can solve it, see if you can make *use* of the particular effect. It is often better to recruit the problem rather than trying to beat it.

TROUBLESHOOTING Problems can provoke and stimulate ideas for photographic images that transcend the ordinary. Here, three obvious problem situations illustrate that the range of troubleshooting in photography goes beyond simply learning how to cope with a jammed roll of film. Photographing a nest of bubbles involved coming to terms with the technicalities and using careful lighting and multiple exposure (FAR RIGHT). The problems set by a fast and dangerous sport meant that it was essential to be in the right place at the right time, and to know how to capture fast action (BELOW). The physical difficulties of composing a dramatic landscape on the slopes of a volcano necessitated proper equipment for the conditions and an awareness of when the best lighting was likely (BELOW RIGHT). The key is to anticipate and respond to the unique challenges of particular moments.

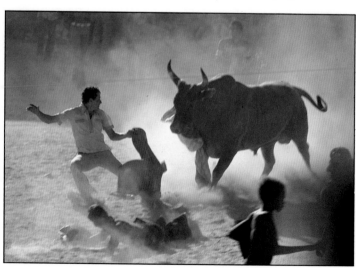

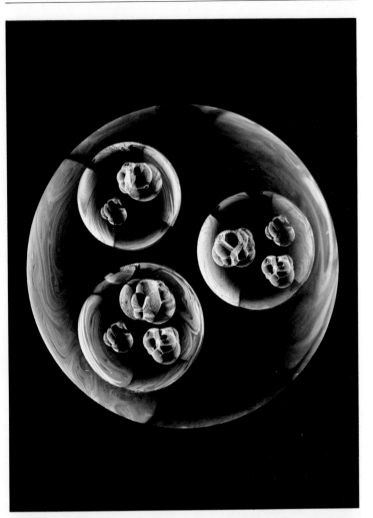

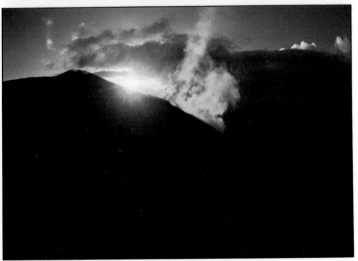

PROBLEM SUBJECTS

Some subjects, like landscapes and flowers, are naturally cooperative and generally slip easily onto film. This first section, however, deals with a different kind - the awkward, less tractable subjects that present difficulties of various types. These are the subjects that, for one reason or another, seem to discourage photography - they are the assignments that many photographers make excuses not to tackle or that bring out a certain fatalism, the approach that somehow the pictures will be resolved through a kind of camera magic.

Some problem subjects tax the technical performance of cameras, lenses and film. Others are simply elusive or place the photographer in an awkward or embarrassing position - much candid photography falls into this category. But many problems are just a question of attitude: either daunting or interesting, depending on how they are approached. Each of the subjects that follow are conventionally difficult but the problems they entail can not only be solved but also regarded positively, providing an opportunity for interesting, original photographs.

FREEZING MOVEMENT

PROBLEM SUMMARY: Movement registers on film as a blur, unless the shutter speed or flash exposure is at least 500 times faster than the time it takes for the image to move across the picture frame.

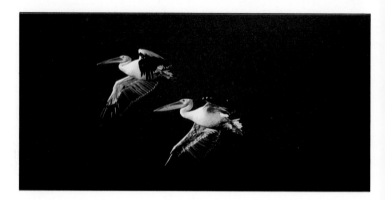

ABOVE Typical of the type of subject where movement really does need to be captured sharply on film, this photograph shows two pelicans flying into late afternoon sunlight over an African lake. The techniques required are neither unusual nor complicated but demand precision: a smooth panning action with the lens, rapid adjustment of the critical focusing, and most important **of all, accurate judgment of** the minimum shutter speed. Panning takes care of the movement from left to right; the shutter speed accommodates the wing movement · 1/250 second at f4.5 just manages this, thanks to a fast lens.

The sharp image is one of the conventions of photography, and although it may not always be desirable for creative reasons, crisp, frozen action is usually a priority when photographing a moving subject. There are just two ways of freezing an image photographically - by adjusting the speed of the camera's shutter or by using the pulse of light from a flash unit - although there are, in addition, a few tricks for making the image appear to move less.

SHUTTER SPEED Before anything else, you must know the slowest speed necessary to freeze a particular action. Increasing the shutter speed generally involves compromise in other areas, such as depth of field or film grain, so there is no point straining to reach a faster speed than you need.

This shutter speed depends on how fast the image moves and not on the actual speed of the subject. However long it takes to cross the frame, the shutter speed should be 500 times faster for a really sharp image, although slower speeds might do if you are less critical or if the photograph will not be enlarged very much. So, if the image of a car, small in the frame, moves through the viewfinder in half a second, use a shutter speed of 1/1,000 second.

Fast shutter speeds need plenty of light. One way of achieving this is to use a fast lens (with a wide maximum aperture), demanding careful focusing; another is to use fast film, which will inevitably be grainier. If there is still insufficient light, try to shoot the subject in silhouette, which can

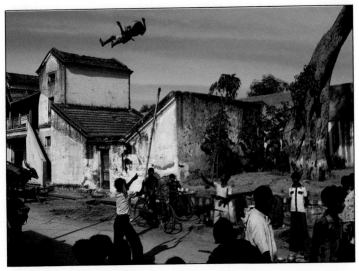

be underexposed yet still satisfactory.

Most cameras have top shutter speeds of 1/2,000 second, but some new models achieve up to 1/4,000 second. Specialized, custom-built high-speed cameras may be the only answer when speeds of several thousandths of a second are needed.

FLASH SPEED Where distances are short, as in a studio, flash may be much faster than a shutter. The problem is that the rapid fall-off of light from small flash heads makes it difficult to light large areas. Electronic flash is much faster (that is, its output peaks more rapidly) than bulb, but the fastest of electronic units are the smallest. The flash from a typical camera-mounted unit can last as little as 1/50,000 second, although at full power it will be slower. A large, mains-powered unit, of 2,000 joules or more, may be as slow as 1/1,000 second.

MAKING MOVEMENT APPEAR SLOWER

● Use a viewpoint from which the subject is moving head-on or diagonally.
● Move back so that the image is smaller.
● Fit a wider-angle lens so that the image is smaller in the frame.
● Pan the action so that the image hardly appears to move in the viewfinder.
● Shoot when there is a dead spot in the action, such as the peak of the arc in a jump.
● Where you have complete control, as with a model, simply have the subject move in slow motion. Make sure, however, that this appears realistic by first observing carefully exactly how the action looks at full speed.

ABOVE Although a fast shutter speed - in this instance, 1/500 second - is the single factor in stopping the action, the role of movement in this scene is treated unconventionally by using composition and timing to create surprise. At the climax of the performances by street acrobats in a small Indian town, a young girl is thrown in the air. Had she been the sole focus of interest in the photograph, the image would have been interesting enough, but by using a wide-angle lens and placing the action well off-center, the picture takes time to appreciate. The apparent lack of concern on the part of passers-by makes the performance seem even stranger.

ENHANCING MOVEMENT

REVERSING THE PROBLEM: When the sensation of speed is more important than precision, introduce controlled blur into the photograph.

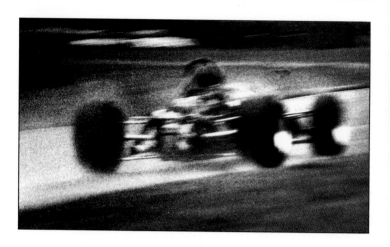

ABOVE A sense of movement can be emphasized in different ways, and certainly does not necessitate the image being sharply frozen. Here, a slow shutter speed (1/60 second) and a technique of panning that lagged slightly behind the racing car, give an impression of speed at the expense of clear detail.

Another convention of photography is that a streaked image will suggest movement too fast for the camera to capture. When the purpose of the photograph is to put across the idea of movement, producing a blur deliberately may be the most effective way of achieving this. On occasions when you cannot freeze the action, controlled blur may also be an acceptable solution.

Generally, the more blur, the greater the impression of movement, but also the more abstract the image. If the subject has a very recognizable outline - a racing car, for example, or a cyclist - it can stand this treatment better than something that *needs* a certain amount of sharpness to show what it is.

Blurring the image of a light-colored subject against a dark background produces a different effect from a dark subject against a light background. In the first case - such as a white bird flying against dark trees - every part of it is recorded as a ghosted image. If, on the other hand, the background is bright, it will wash out much of the moving subject.

CREATING BLUR

● **SLOW PAN** Pan the moving subject normally, but use a very slow shutter speed - 1/15 second or slower. This will convert the background into streaks, and also cause some streaking of the subject.

● **ZOOM AND PAN** Pan exactly as above, but use a zoom lens and operate the zoom con-

trol while shooting. This exaggerates the streaking and focuses attention on the subject.

● **ZOOM** Even with a stationary subject, zooming the lens while the shutter is open gives an impression of movement toward or away from the camera. This is most effective head-on to a subject. Use sparingly, as this is a clichéd technique.

● **TIME EXPOSURE/FIXED CAMERA** The reverse effect of a slow pan - here the background remains sharp. This is particularly useful for a shot of milling crowds in the distance.

● **CONTROLLED SHAKE** Move the camera randomly while shooting. This works best with a long-focus lens; the effect is a little similar to a slow pan, but the streaking is not so definite.

● **MULTIPLE EXPOSURE** Using a motor-drive set on 'continuous', press the lever for multiple exposure (the winder 'clutch'), and shoot as the subject moves. The effect is of a stepped, ghosted image. Remember to reduce exposure (two exposures on one frame equals one stop less, four exposures equals two stops less, etc).

● **STROBE FLASH** In the studio, use a special stroboscopic flash that gives a rapid sequence of pulses. Keep the background very dark (black velvet is best). If the subject moves across the frame (for example, a runner), make no adjustment to the exposure; if there is only partial movement (for example, a tennis player serving), reduce the exposure by experiment.

● **FLASH AND TIME-EXPOSURE** Use a long exposure to create blur, and a single flash to give a sharp image of the subject at one point. Base the exposure on the existing lighting and adjust the flash output to suit. Bracket exposures to be certain.

LEFT Even with a conventionally fast shutter speed (1/500 second) and a panning technique, the impression of speed can vary. Timing the exposure for the split second when all four hoofs were airborne - in itself a difficult feat - and also catching the backlit spurt of dust, enhance the sense of action here. Because of the uncertainty in timing, and the precision needed to capture the excitement in a good picture, it is often worth taking a sequence of photographs in this kind of situation.

PARADES AND EVENTS

PROBLEM SUMMARY: Find and reach a position with a clear view of the main event, even if you have never seen the particular event before.

Although parades and ceremonial events offer opportunities for a rich variety of shots - costumes, details of floats and spectators -there is always one key shot that is far and away the most important. This is an unobstructed view of the procession at its height, with the maximum activity and color. Put all your efforts into this key shot; the others will follow easily.

RESEARCH THE EVENT The first step is to find out the date, route, timing and what there will be to see. Mark all the information on a street map. If the parade is a popular tourist attraction, a travel agent may have all this information, as may the local tourist office, but the best source always will be the organizer of the event. Start making enquiries several days before, if you can. If for any reason you cannot reach the organizers, simply ask as many local people as possible until you have a consensus. Look for any pictures of past parades in magazines, brochures or on postcards; these will give you an idea of what to expect.

GET PERMISSIONS The larger and more organized the event, the more restrictions there are likely to be. On the day, the police may clear some positions completely; others will be restricted to pass-holders, and access routes may be blocked off some hours before. The organizers are the

BELOW State occasions, such as this attendance by The Queen at a ceremony in St Paul's Cathedral, London, are among the most photogenic of ceremonial events. Virtually without exception, there is one peak moment that is, at least in content, the high point of the day. On this occasion it was the appearance of The Queen and the Duke of Edinburgh, together with the Lord Mayor of London, on the steps of the cathedral.

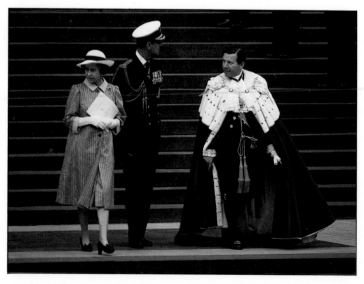

best source of official permissions, although it will help immeasurably if you are a journalist. As a precaution, it might be worth checking at the local police station. Remember that what you are looking for is one good position.

MAKE A RECONNAISSANCE Whatever information you have been given, nothing beats an on-the-spot check. From a position you have been recommended or allocated by the organizers, the branches of a tree or a similar obstruction might be in the way. Walk over the route yourself, and imagine how it will look full of crowds. A telephoto shot is likely to be the most effective, but where will the sun be on the day? Is it likely to cause flare? An elevated position is usually clearest, but beware of overhead wires or cables. From ground level, a junction or bend in the road facing the oncoming parade may be good, but you may have to arrive early for a front-line place. Traffic islands may look ideal, but are likely to be cleared by police. The safest locations are often private houses or stores - look for one with a balcony and ask permission from the occupiers.

ARRIVE EARLY AND PREPARED The earlier you reach your position the safer, whatever permissions you have. Assume you will not be able to move until the parade is over, and take more than enough film, a spare camera body and sufficient lenses. A tripod may be useful, together with something to stand on and waterproof clothing.

BELOW Planning the photograph of The Queen at St Paul's (LEFT) involved making a reconnaissance a week before – sufficient time to find the best camera position and arrange permission to use it. One unexpected, yet not atypical problem was that a statue was found to obstruct the crucial view from the ground level. From a balcony, higher up, the view was clear. Photo-journalists used to working from this location are familiar with the problem, newcomers face an unpleasant surprise.

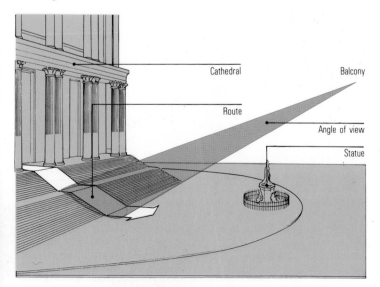

Cathedral

Route

Balcony

Angle of view

Statue

CROWDS

PROBLEM SUMMARY: In a situation where everyone is competing for a clear view, advance preparation and a little ruthlessness are needed to get in front of or above the crowds.

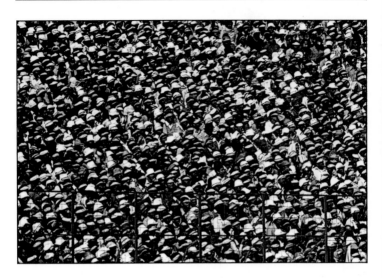

ABOVE Although crowds are an obstruction when they block the camera's view of the subject, they can make good pictures in themselves. When there are crowds directly facing the camera, a long-focus lens can crop into the view sufficiently to create a packed, massed image. This cricket match in Calcutta provided an ideal opportunity for such a composition; a 500mm lens excluded the surroundings effectively.

Special events that are interesting and important to photograph, such as sports fixtures, parades and festivals, often attract crowds. Mainly, crowds are a real obstruction to photography; using a camera calls for more room and a clearer field of view than just looking. To beat the crowds, your single aim should be to reach the front or find a higher position.

FIND OUT WHERE THE CROWDS WILL BE Ask security personnel or police where the public will be allowed.(It is no use installing yourself in a position that will be overrun when the crowds arrive.)

TALKING YOUR WAY TO THE FRONT Arriving early is the best way of ensuring a front-line position, but if you cannot, you might be able to use your appearance and equipment to convince people that you have some sort of journalist's priority. Don't rely on it, however - no one likes to give way to a latecomer. Smile, be very polite, and act as if you have the right to be at the front. Occasionally this works with officials in front of the barricades.

GAINING A FEW INCHES If you are stuck in the middle of a crowd, there are still ways of gaining height. The best is to have something to stand on, such as a metal camera case, a milk crate, or even a lightweight step-ladder (standard equipment for press photographers at major

events). Otherwise, take a chance on the framing and hold the camera above your head, aiming blindly. If you can remove the prism, hold the camera upside-down overhead and look straight into the viewing screen - difficult but possible.

REVERSING THE PROBLEM: Include crowds in the picture to enhance the sense of occasion.

For all the physical difficulties of crowds, they bring an undeniable excitement to major events. By using a wide-angle lens and deliberately including the heads of the surrounding crowd you can capture some of the feeling of the occasion. From a distance, facing the crowd (easy in a stadium), a long-focus lens will give a compressed, massed view that can be as powerful a shot as any of the event that the crowd is watching. For these reasons, don't be obsessed with the need to keep crowds out of every picture.

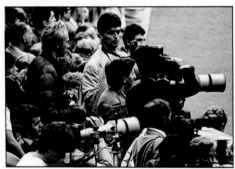

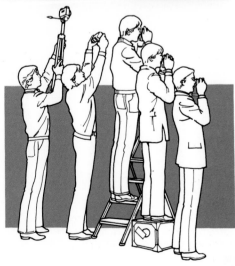

LEFT At a special event, press photographers generally take few chances in their quest for good pictures. Front positions belong to those who arrive early; few concessions are ever made to latecomers or other spectators.

BELOW If the view of the main event is blocked in front, there are three standard solutions that are generally adopted by professional photographers: holding the camera overhead, either on a tripod using a self-timer, or upside-down looking directly into the focusing screen; standing on a portable step-ladder; or standing on a sturdy camera case.

PORTRAITS

PROBLEM SUMMARY: Most people are naturally tense and shy about being photographed. Certain techniques will also help to ensure that the portrait is either flattering or reveals character.

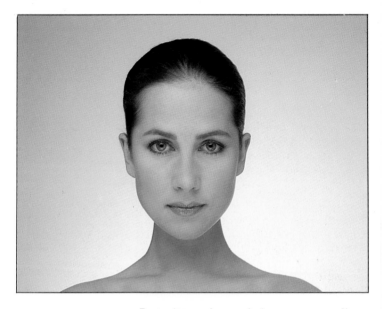

ABOVE Although variations in the lighting set-up can do much to establish differences in character and mood, the clearest and least obtrusive arrangement is a single, very well-diffused lamp, placed above and in front of the sitter. In this example, the light was enclosed in a box, fronted with a 2 x 3ft (0.6 x 0.9m) sheet of opal plexiglass, and shadows were dramatically reduced by two white panels on either side of the girl's face. Lighting the background separately helps to make the subject stand out clearly.

Portraits can be made in any surroundings - outdoors, at home, or in a studio - but always have some feeling of deliberation. This formality can suit the style of a serious, face-to-face portrait, but more often the session is more productive if the subject is at ease. The key to bringing spontaneity to a portrait is preparation; cover all the technical aspects and take most of the creative decisions beforehand. The more portraits you take, the easier it becomes.

SIMPLE TECHNIQUES FOR A BASIC PORTRAIT The sitter's personality and your own attitude may dictate different approaches; if you are trying to bring out a specific quality of a person's character you may not necessarily want to flatter. However, under normal conditions, the following tips should help to smooth out a portrait session.

● A LONG FOCAL LENGTH FLATTERS THE FACE By compressing perspective, a long focal length makes the nose less prominent and gives more pleasing proportions than a standard or wide-angle lens. 105mm or longer is ideal.

● FOCUS ON THE EYES Heads are relatively deep from a full-face view and depth of field is a common problem. However, as long as the eyes are sharply focused, slight

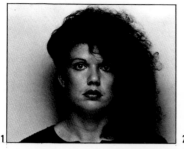

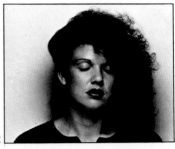

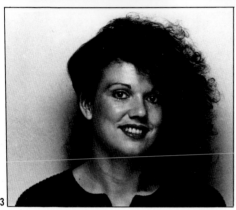

POSING FOR THE CAMERA In photographing anyone not accustomed to being a portrait subject, a frozen expression is likely, particularly if the occasion is not relaxed. Compounded of a mixture of embarassment and trying hard to hold an expression, a stare will simply become worse without remedial action (1). One straightforward method is to tell sitters to close their eyes (2) or look away, and then to call them back to look at the camera (3). Any method of breaking the tension is equally valid.

softness elsewhere does not normally matter.

● **KEEP THE BACKGROUND SIMPLE** In a head shot, the background is likely to be out of focus, but any variation in tone may be distracting and divert attention from the expression.

● **PREVENT AWKWARD STARES** Make the sitter glance away and then back at you for a fresher look.

● **KEEP SHOOTING TO CREATE CONFIDENCE** Even if your subject is still feeling, and looking, awkward, keep taking pictures and say that they are working well. This is likely to encourage relaxation and self-confidence.

● **KEEP UP A FLOW OF CONVERSATION** Small talk reduces the sense of occasion in a portrait session and helps most people to relax.

● **BEWARE OF BLINKING** If a blink coincides with the shutter firing, it will ruin the portrait. Shoot liberally to allow for this.

● **DON'T SHOOT FROM BELOW** A low camera angle makes the head look smaller in relation to the torso and also makes the chin prominent. Neither effect is very flattering. For more 'presence', ask the sitter to lean toward the camera.

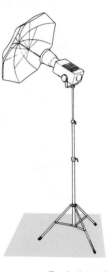

LIGHT ON STAND The simplest and most useful lighting equipment for portraiture is a single studio flash, mounted fairly high - about 3ft (0.9m) above the subject's head, and possibly to one side - on a stand with a white or silvered fabric umbrella. Although not as precise as a diffusion box in its effect, an umbrella softens shadows and can be folded for carrying.

POSES

PROBLEM SUMMARY: With a non-professional model, it is easy to run out of ideas for interesting and relaxing poses.

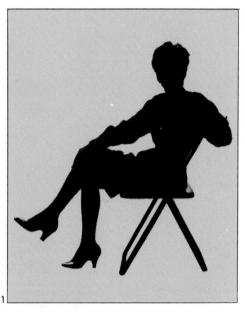

TYPES OF POSE The function of a pose is not only to present an attractive overall shape, but also to relax the subject. These are essentially comfortable rather than stylized poses, and are sufficiently conventional to suit people who do not have experience of being photographed. Although the full-figure pose is shown in all these examples, the positions may also be used for head-and-shoulders portraits.

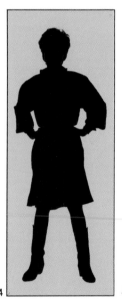

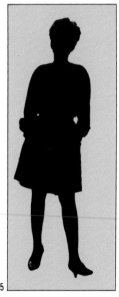

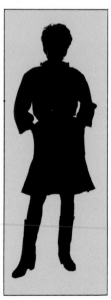

Without a definite idea of a pose, a portrait subject can quickly feel awkward and uncomfortable, and this can spoil the atmosphere of the session. Some specific poses are useful because they are photogenic, others are useful because they help the subject to relax.

Chairs of a simple design make good standard props for sitting in (1), leaning against (2) and as a support for one foot (3). For anyone who is particularly nervous a chair is useful as then hands and arms can be positioned easily.

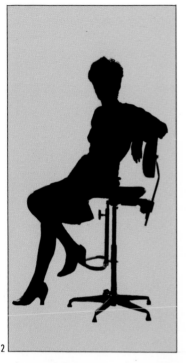

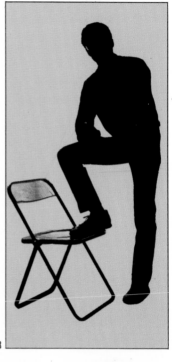

2

3

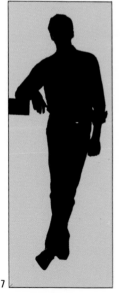

7

8

9

Standing poses sometimes worry inexperienced subjects because they offer no support, yet in practice they are quite easy, if the photographer gives directions. Most people pay too much attention to the position of their hands, and so become tense and awkward; pockets are useful in this case (4, 5, 6). Reassure your subjects and suggest any of the poses illustrated.

To prevent stiff leg positions, suggest that the subject places his or her weight onto one foot (7, 8) or that he or she moves around. The assertive pose (9) is suited to naturally confident people.

CHILDREN'S PORTRAITS

PROBLEM SUMMARY: Although more spontaneous than adults, children are less tractable as portrait subjects, and lose interest quickly.

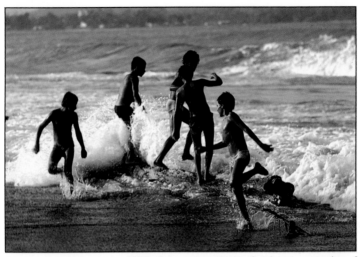

ABOVE Photographing play is usually the easiest way of capturing spontaneous images of children. Even if, as in this photograph, the children are entirely aware of the camera's presence, the momentum of the occasion will generally take over and there will be little opportunity for self-consciousness or acting. The further back the camera position (and so the longer the focal length of lens for a tight shot) the more likely the children are to behave naturally.

With few exceptions, the best portraits of children are those that look natural, taken when they are not paying full attention to the camera. The finer points of photography, certainly the technical ones, are too abstract to command the interest of most children; the rigmarole of setting up lights, camera and making fine adjustments is likely to bore them. Moreover, a child's moods are often volatile; you stand a better chance of capturing good expressions and actions if you photograph when the child is in the right mood.

● **PLAN AHEAD** Make all the technical preparations that you can before the session, so that you can react quickly to the child's spontaneity. Choose the location, lighting, lens, film and exposure settings.

● **TAKE ADVANTAGE OF SPONTANEOUS MOMENTS** When children are already involved in something they enjoy, exploit that opportunity, even if you had not planned to and even if the circumstances are not perfect photographically. Candid shots are often the best of all.

● **CREATE THE RIGHT ATMOSPHERE** Set up a situation which the children are likely to find absorbing, though not ostensibly a photographic session. Consider favorite toys for young children, games for older ones.

● **STIMULATE INTEREST** It may work, par-

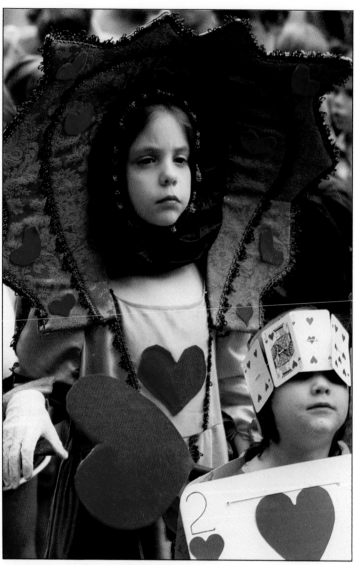

ABOVE A perfect opportunity for candid photography, a fancy dress competition based on the theme of Lewis Carroll's 'Alice in Wonderland' provides an occasion where the children are oblivious to all but the roles they have adopted for the day. The studied seriousness of the Queen of Hearts and her younger acolyte bring a touch of humor to the event. Again, taking the photograph with a long-focus lens from a distance made it possible to capture candid expressions.

ticularly with older children, to recruit their interest by involving them in the photography.

● **AVOID BOREDOM** Whatever the situation, pursue it only as long as the atmosphere is working well. Don't push a child's interest beyond its natural limits.

UNWILLING SUBJECTS

PROBLEM SUMMARY: For any number of reasons, including protection of privacy and deep-rooted social attitudes, people may object to being photographed or else act unnaturally in front of the camera. Overcoming this resistance depends on how badly you want the photograph and demands tact and diplomacy.

Because cameras are so common, many photographers quite wrongly assume that anyone is fair and willing game as a subject. Faced with an abrasive or intrusive attitude on the part of the photographer, most people will react in a prickly fashion. The problem of unwilling subjects can in most cases by solved before it occurs by being pleasant, cheerful and sympathetic. A smile is the most disarming of techniques.

Given that you take a reasonable attitude, you will still find people who do not want to be photographed at all. Before proceeding, you must find out why. In some parts of the world the problem is intractable - photographing women in Islamic countries is very unwelcome, especially if you are a man. In others it is a general social attitude that can be overcome, but with difficulty - most American Indians see photography as not just intrusive but a form of cultural exploitation. In yet other situations the reason may be idiosyncratic - for instance, someone may feel that he or she is not attractive enough to photograph. If

BELOW Religious activity is a delicate subject and a camera may well be regarded as an offensive intrusion. A persistent attitude in Islamic societies is the belief that, by recording their image, the photographer robs his subjects of something essential. For this picture of Pathan tribesmen at prayer, prior permission was essential and a telephoto lens was used to be less noticeable.

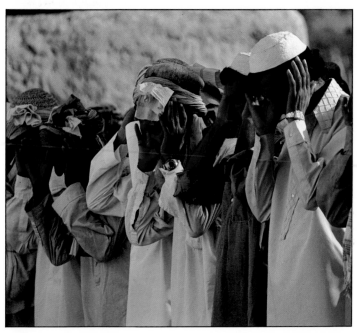

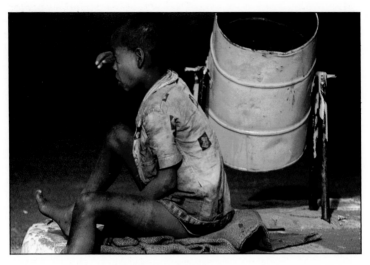

you know why a person is unwilling, you can tailor your approach accordingly.

AVOIDING THE PROBLEM One solution, if you expect resistance, is to take the pictures candidly. This normally means either concealing yourself (shooting with a long-focus lens from a balcony, a shaded doorway, or similar hidden places), or pretending to shoot something else (aiming off with a wide-angle lens, or removing the prism and shooting with the camera on your lap). The risk is embarassment or argument if

ABOVE Basic candid photography, using a long-focus lens and fast camera handling, is one way of bypassing any possible resistance on the part of the subject. Speed, however, is essential; the risk of being spotted is the loss of the shot and possible embarrassment. Any subjects showing poverty, especially in a country sensitive to such issues - such as India - are best tackled surreptitiously. LEFT Another type of situation that is likely to be difficult to photograph are those where activity of questionable legality is taking place. Drugs usually fall into this category; to take this picture of a hashish shop, the photographer had to engage in an hour of relaxed conversation before even unpacking the camera.

UNWILLING SUBJECTS/2

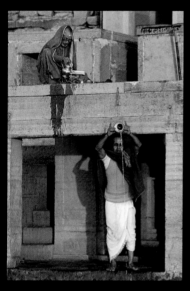

LEFT People at prayer, as in this scene taken on the Benares ghats in the early morning, may make an interesting subject for photography but are likely to resent the trivial intrusion of the camera, reasonably so. Taking the picture with a long lens from a fair distance avoids the problem.

CENTER A more direct technique, and one that is more sympathetic to the interests of the subjects, is to introduce the camera to the people you wish to photograph. Children, in particular, are fascinated by gadgets.

BELOW As this photograph of women examining Polaroids in Thailand shows, instant prints are welcome in nearly every situation.

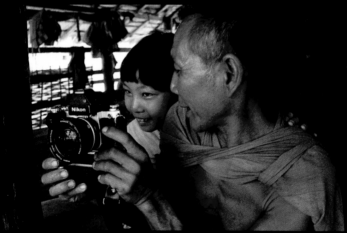

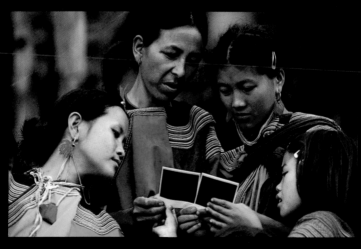

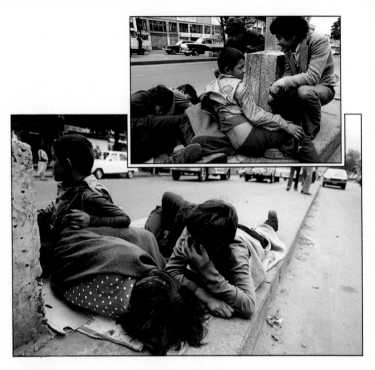

you are caught in the act of taking the shot.

CREATING GOODWILL More satisfying if you are able to handle the situation well is establishing a friendly relationship before you attempt to take pictures. Practically any situation can be turned around with time and patience, but with some tribal groups, for instance, the time involved may be weeks rather than minutes.

One method is to use a local guide, preferably from the same community. His interests will bridge the gap between you and your subjects. Another established method is not to unpack the cameras at the start, but to open a casual conversation and continue until you have reached the right level of rapport.

Particularly if there is a language barrier, you might play on people's curiosity. This is most effective with children, and once they are on your side, the attitude of the adults will often follow. Encourage the children to play with the camera and even have them take one or two pictures themselves.

A final inducement is a portrait print for your subject, which puts you in the position of offering a service rather than just benefiting yourself. Far better than a promise to send a print is an instant picture.

ABOVE Some situations are so potentially difficult that local assistance is essential. Photographing 'gamines' - homeless children who form street gangs in Bogota - was only possible by recruiting the help of a social worker, himself a former gang member. This type of preparation, although it may rule out spontaneity, can make all the difference; in this instance it allowed the photographer to take a close, wide-angle shot that showed the unpleasant urban surroundings.

PROFESSIONAL MODELS

PROBLEM SUMMARY: If you are unused to working with professional models, you may expect too much or too little from them.

Apart from the particular appearance of a model, the important quality that you are paying for, and should expect, is professionalism. An experienced model should be able to suggest ideas and poses and even an inexperienced model should have initiative.

CHOOSING A MODEL Most models have agents, and the agency is usually best equipped to suggest a model once you have described what you are looking for. Be as specific as possible about the qualities you want; it is often useful to refer to the type of models used by particular magazines. If you are going to photograph just one part of the body, such as hair, legs, eyes, or lips, ignore the rest of the appearance. Some agencies specialize - for instance, in young girls, male models or character models.

Collect composites - large index cards that show different photographs of a model and give measurements.

FEES AND RELEASES Fees are normally quoted by the hour or day, with very popular models commmanding a premium. If you deal directly with the model instead of going through an agency, and pay cash, the cost will be less. Some agencies are willing to allow photographers to shoot a test without charge in return for free photographs for a young model's com-

BELOW When choosing a model for the first time, the most useful guides are the composite cards issued by agencies. 'Reading' the cards demands some experience; most aim to show the variety of characterization which the particular model is capable of portraying. Try not to take the pictures on the card too literally - they are designed to show versatility rather than stereotypes.

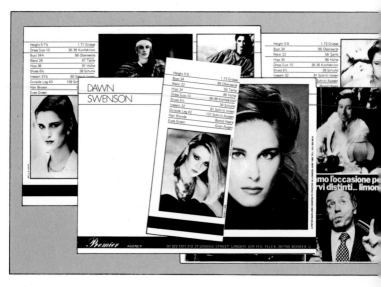

posite; this is a useful way for both photographer and model to gain experience.

Explain at the start how the pictures will be used, and after the session always have the model sign a 'model release' form. This confirms your right to use the pictures.

WHAT TO EXPECT FROM A MODEL As well as enthusiasm for the job you can expect the following:

● A basic wardrobe that is up-to-date. Agree beforehand which clothes the model should bring.

● The ability to do basic make-up and a variety of simple hairstyles.

● The model should know his or her best and worst features, and the angles that show them off.

● An ability to fall quickly and easily into a variety of poses and expressions.

WHAT NOT TO EXPECT FROM A MODEL

● Specific clothes, hairstyles and make-up are your responsibility.

● No model can guess what you want. You will have to explain.

● Posing naked or in any very unusual fashion, without prior warning.

WHAT A MODEL WILL EXPECT FROM YOU

● Direction. Someone has to control the session, and that can only be the photographer.

● Encouragement. Throughout the session, give the model at least a clue as to what seems to be working best.

● Pleasant atmosphere. Models work better when relaxed. Music may help.

BELOW However unnecessary it may seem at the time of shooting, a model release form is essential. The model should sign it immediately after the session to avoid subsequent misunderstandings about how the pictures will be used. If you are working on commission, it is part of your responsibility to your client to ensure that there will be no dispute over use of the photographs.

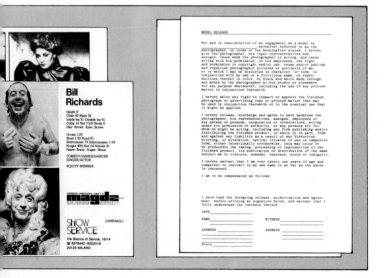

FINDING LOCATIONS

PROBLEM SUMMARY: Finding an exact location for a specific photograph is much more difficult than choosing a generally suitable area. Only reconnaissance or up-to-date picture reference is reliable.

Location shooting, where a photograph is planned ahead of time and organized in an outdoor setting, is chiefly a professional problem. Because the idea is worked out in advance, there is a temptation to detail the image precisely. If so, it may be almost impossible to find a real equivalent of the idealized setting. For this reason it is best to keep an open mind about the location as far as possible and list only your basic needs (for example: 'sandy beach - nothing manmade in sight - elevated viewpoint'). An area that is generally suitable is more likely to provide views that meet the specifications but are not exactly what you expected.

If you do need an exact location, the most reliable method of finding is by making a reconnaissance beforehand in a likely area. This is time-consuming but the only

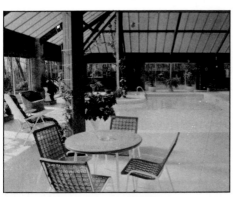

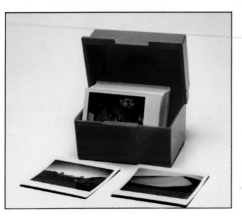

way of guaranteeing the shot. Otherwise, if you rely on luck on the day of shooting, you may easily find that the smallest details ruin the location (for example, the viewpoint may be just a few feet too low, or overhead cables may appear in the shot). The time factor necessarily restricts the distances you can consider properly but a map may indicate possibilities.

The second-best alternative is to find an existing photographic reference and then design the shot to fit. Sources include personal files, travel brochures, magazines, and books or guides that feature scenic views.

Some photographers keep a record of attractive and potentially useful locations that they come across on their travels. For easy reference, instant prints with details written on the back can be filed in a card index. Check whether you would need permission to use the location when you are there. When taking reference shots, photograph not only the potential view, but also the wider setting to show where cameras and lights might be positioned.

RECORDS OF LOCATIONS A photographer can keep a personal file of specific or memorable places, building up a card index of instant prints. These may be divided up into countries, points of particular interest, interiors/exteriors, types of view, city/sea/landscapes etc. Details about the various ways the view could be used, and how altered by filters, lenses and props should be written on the back. For professional photographers, agencies that specialize in location reference are invaluable. If a photographer needs, for example, a kitchen that could be dated to a specific period, or a bedroom decorated in a certain color such an agency will provide a suitable location as well as permission from the owner. These three pictures – a country dining room, a kitchen from a Sussex house, and an indoor swimming pool in Kent – have all been provided by an agency that has over 250,000 locations on file.

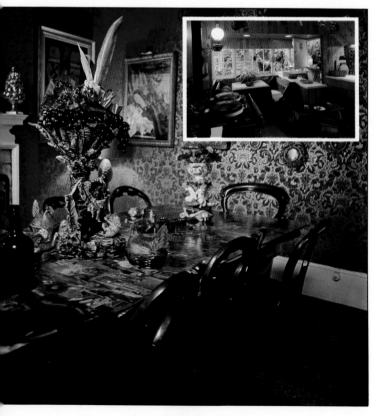

SPECIAL SETTINGS

PROBLEM SUMMARY: For subjects that need the photographic equivalent of a stage setting, the problem is to be convincing in atmosphere as well as in detail, and to do so at an affordable level.

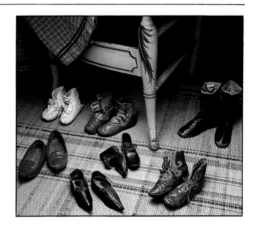

RIGHT Although the types of set that it is possible to construct for still-life subjects vary widely in scale and complexity, all have one purpose in common - to give the impression of reality. With a tightly cropped shot taken at a downward angle, very few props need to be used. Here, a period chair and a suitable carpet, simply arranged, are all that are required to provide both the scale and style necessary to display this small collection of Victorian children's footwear. Such historical, personal subjects benefit more from a contextural setting than from an abstract backdrop.

For still-life and fashion photography in particular, more than just a simple, complementary background may be required. The idea of a special setting is to create a scene into which the subject appears to fit naturally. In scale, settings can vary from a table-top surrounding for a small still life to an entire room set. Settings can also cover a wide range of style; the most common type is period reconstruction, the creation of a specific historical atmosphere.

Atmosphere, in fact, is one of the main qualities of a successfully created setting. Without flair, even the most authentic props will remain simply a collection of objects; on the other hand, it is possible to create a strong impression using only a few, strategically placed accessories and careful lighting. If a set will be too complex to assemble easily, consider looking for an existing location instead (GO TO PAGES 30-1, FINDING LOCATIONS).

RESEARCH The key to convincing set design is thorough research. To research period reconstructions, check magazines and books on the subject; contemporary illustration, including paintings, engravings and photographs; museums; restored and preserved buildings; and prop hire companies. Note in particular how contemporary illustrators lit and composed their views. Imitating visual styles greatly helps authenticity.

DECIDE ON A LAYOUT Either sketch the layout of the shot and then plan the design and

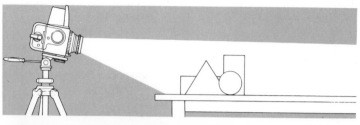

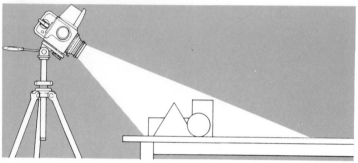

construction of the set to suit it, or collect more props and materials than you need and leave final decisions until the end. The advantage of the first alternative is that little is wasted in construction, assembly or hire charges for props, but it may be difficult to find exactly what you want. The second alternative allows the possibility of a different composition being suggested by an attractive prop. In either case, only the picture area needs to be filled; half of a room set is the most that ever needs to be built, and structural materials do not need to be genuine.

COLLECT THE PROPS In cities where there is a professional photographic, video or movie industry, there are usually companies from which you can hire props, varying from furniture and costumes to small accessories. Stores, in particular antique shops, are another possible source. Offer to pay the full price as a deposit, from which a percentage for rental (generally 10 percent per week) can be deducted when you return the object. You may be able to borrow new items free from the manufacturer.

USE LIGHT FOR ATMOSPHERE Lighting design can add greatly to the overall impression. With period sets, consider using the style of lighting most common in contemporary illustration. A mild soft-focus filter sometimes helps a period shot. Other techniques include sepia-toning or hand-coloring, and imitating contemporary composition and poses.

CAMERA ANGLE The size of the area that needs to be converted and decorated makes an enormous difference to the work that will follow. Camera angle often determines the amount of set construction necessary. A tight shot down onto a desk or table will only call for a few props and will avoid the problem of having to install structural items such as doors and windows. A horizontal camera angle, on the other hand, particularly if combined with a wide-angle lens, will include more background in the shot and this can mean that disproportionate effort is spent in preparation. In extreme cases, even an entire room set may have to be assembled and built.

LANDSCAPES

PROBLEM SUMMARY: Many of the best shots of natural landscapes are marred by people and signs of human presence.

ABOVE For landscape photography, aircraft contrails are a particularly intrusive kind of visual pollution, and usually more visible on the photograph than to the naked eye. With wide-angle views such as these, which are of Fisher Towers in Utah, there may be little chance of another camera angle that is as good. In such a case, time, and a strong wind, are the only answer; it took nearly an hour for these trails to disappear from the sky.

In wilderness areas such as national parks completely 'natural' views are increasingly difficult to find. Buildings, roads, telegraph poles, tourists and cars encroach constantly and the most famous viewpoints in any area attract many visitors. Even litter and footprints can be a nuisance. Use these methods to avoid human traces:

● **ALTER THE VIEWPOINT** If a car-park or similar eyesore is obstructing the view, move the camera position until a natural feature - a bolder, tree or ridge, for example - obscures it. With a wide-angle lens, moving a few feet can change the foreground of the image drastically; often, just shooting from closer to the ground is sufficient.

● **CHANGE TO A DIFFERENT FOCAL LENGTH** Use a longer focal length for a narrower field of view to crop man-made objects out of the picture. Alternatively, if the view has to be sweeping and there is no way of avoiding people or their traces in the distance, it may be possible to use such a wide angle that these elements become a tiny, insignificant part of the image.

● **WALK FURTHER THAN ANYONE ELSE** At tourist sites, visitors tend not to venture far from car-parks. The further you walk off the trail, the fewer people or tracks you will find.

● **START AT DAWN** Relatively few people are out before sunrise. Even at popular sites you have a good chance of being alone.

● **SHOOT IN THE OFF-SEASON** In the summer in Death Valley, or winter in northern Scotland, visitors are scarce. These un-

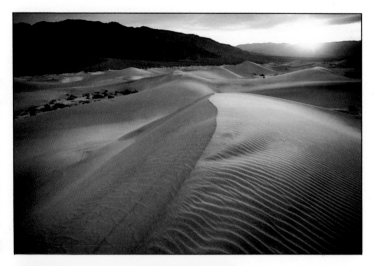

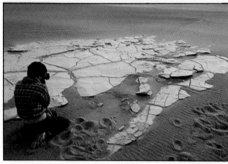

Deserts, beaches, marshes and similarly naked wilderness areas suffer greatly from footprints, often of sight-seers trying to find the most photogenic view. Two techniques are essential, and are illustrated by the photographs (ABOVE and LEFT) taken in Death Valley, California. Walk further than any other visitor, and plan your own approach so that it does not appear in the direction you choose to shoot.

popular times are often more convenient for photography. Check with local hotels for seasonality.

● **USE SHADOWS TO CONCEAL TRACES** Distant objects, roads and tracks can sometimes by hidden by shooting when they are in shadow or in twilight. This is particularly true of footprints in snow or sand, which in brighter conditions would be prominent.

REVERSING THE PROBLEM: Instead of avoiding signs of people, include them in the photograph to show that modern landscapes are rarely natural.

Deliberately excluding people from the image in order to create an illusion of wilderness is often a misrepresentation of reality. This approach may be more pictorial or graphic, but it is also rather romantic. The untrameled landscape is something of a convention in photography, one that can usefully be broken by showing how people intrude.

35

CITYSCAPES

PROBLEM SUMMARY: The high concentration of buildings in most cities makes it difficult to find single clear images that can capture their character. Cities lack the freedom of viewpoint characteristic of most landscapes.

Good clear views are scarce in cities; these need either height or a clear open space. For a thorough check of the best sites, start by looking at the views on postcards or tourist brochures and locating them on a map. Then, follow up with on-the-ground reconnaissance, watching out all the time for any high points visible from street level.

Obviously, the viewpoints for each city are specific, but there are some common denominators. Typical high points are prestige tourist attractions such as telecom towers (usually easily accessible, with viewing platforms), high-rise office buildings (less easy for security reasons-ask the caretaker or take a note of the building's owners and telephone for permission to visit the roof area), and overlooking hills. The highest of viewpoints is from an aircraft; hiring can vary from easy to impossible, but usually presents few problems in a developed city geared for tourism, such as San Francisco or Miami, where sightseeing flights are available and often inexpensive (check at the tourist office and local airport). (GO TO PAGES 50-1, AERIAL VIEWS.)

Typical open spaces that give ground-level clearance are the 'lungs' of a city (parks, parade grounds and recreation areas), rivers and bays (use the opposite bank, a ferry or a pleasure cruise) and, oddly, cemeteries (flat and sacrosanct). The choice of which viewpoint to shoot from is influenced strongly by famous or characteristic buildings - a clear view of suburban sprawl is not likely to distinguish, say, Paris or London from many other cities. Look for a specific focus of interest in an overall shot; it is not the only treatment for a cityscape, but it does concentrate attention.

At any of these viewpoints there may be a wide choice of images, from wide-angle panoramas to tight, compressed long-focus shots. Lighting conditions are just as important as they are for landscapes; interesting weather and the time of day are key factors.

COMPOSITE APPROACH The physical complexity of a city can usually be better treated with a variety of images than with a

VIEWPOINTS These examples of cityscapes show three basic and workable methods of taking a clear establishing shot of a city. A wide panorama can be achieved by taking the picture from a high-rise building or from an overlooking hill (TOP RIGHT). An inexpensive helicopter tour provided an aerial shot of Miami Beach (CENTER), while the long-focus view of the east bank of the city of Benares was taken across an open area, in this case across the River Ganges (BELOW RIGHT). Where choice of viewpoint is limited, as from a tall building or across an open space, lighting, and so the time of day, is critical. Aerial photography offers such a variety of camera angle that lighting is usually a less crucial component of the image.

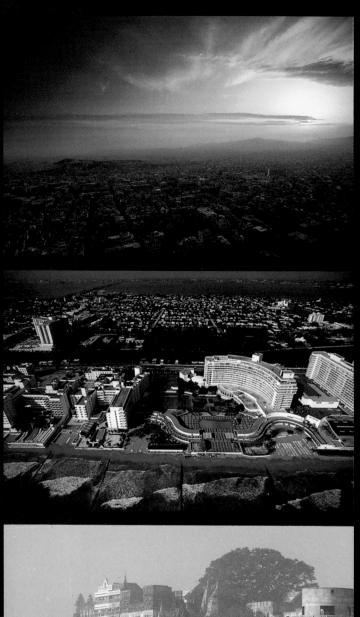

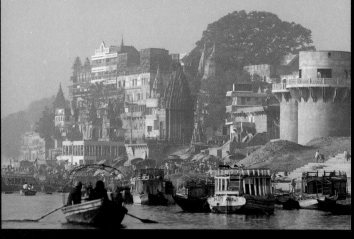

Variety of viewpoint and differences in scale are essential for building up a composite view of a city. These three photographs of Greek monuments in Athens are sufficiently different in approach to complement each other and can therefore be reproduced together in a photo-essay or displayed successfully together. The old portrait camera gives an indication of the social context (TOP). The early morning view of the Acropolis is a basic shot which establishes the location, taken from a researched viewpoint at a well-chosen time of day (ABOVE). The long-focus close-up of columns provides a more graphic image (RIGHT).

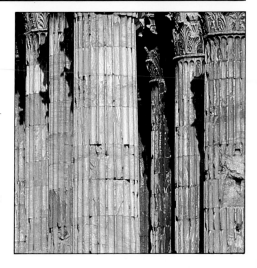

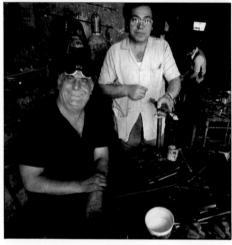

No portrait of a city is complete without at least a few photographs which concentrate on those who live and work there. Street scenes or people engaged in typical work make good subjects. These two photographs, taken in Athens, show people who, in different ways, help to characterize the city. Costume or ceremonial dress can be particularly evocative of a city and its inhabitants, as this photograph of one of the palace guards being dressed for parade shows (ABOVE). The other image, with welders posing for an impromptu portrait, just as effectively captures the personality of the city (LEFT).

single photograph. What often works well is to balance a large-scale overall view with more intimate views of street life. On an intermediate scale, views of busy streets are usually most successful end-on with a long-focus lens.

People in cities provide an inexhaustible subject, largely the province of candid photography. Look not only for people walking and shopping, but those working -bus drivers, police, window-cleaners on high-rise blocks, street salesmen, and so on. (GO TO PAGES 24-7, UNWILLING SUBJECTS.)

Another, even smaller-scale subject is street furniture - details of architecture, shop windows, billboards and the like. Carefully selected, these can help build up a composite picture of an urban area.

TALL BUILDINGS

PROBLEM SUMMARY: Tilting a camera upward to frame the whole of a building produces a tapering image.

Most tall buildings can only easily be photographed from nearby at ground level. Tilting the camera upward seems a normal approach, but in the photograph the vertical sides of the building will appear to converge unnaturally.

To avoid this, the *film* must be upright; in other words, the camera must remain level, and not be tilting at all. Use one of the following methods:

● **RAISE THE CAMERA** Look for an elevated position opposite.

● **CROP THE PRINT** Use a wide-angle lens, keep the camera level, and crop off the wasted foreground when printing.

● **INCLUDE AN INTERESTING FOREGROUND** Use a wide-angle lens, keep the camera level, but find a viewpoint from which some interesting foreground details appear.

● **USE A SHIFT LENS** Specialized architectural lenses, known as shift or perspective-control lenses, can be moved up or down in their mounts. What this does is to move different parts of the image in front of the film. Aim the camera horizontally, then shift the lens upward until the whole building appears in the frame.

● **USE A LONG-FOCUS LENS FROM A DISTANCE** If there is a distant viewpoint, the camera will hardly need to be tilted at all.

● **RESTORE A TILTED IMAGE BY TILTING THE ENLARGER** When printing a negative that has converging verticals, tilt the baseboard and the enlarger head in op-

BELOW These four photographs, which are of a ruin in the Nevada ghost town of Rhyolite, illustrate convergence and how it may be avoided.
1. A 35mm lens was tilted up without any special precautions, and the result is typical convergence of the building's straight sides.
2. By using a shift lens, and moving the barrel upwards in its mount, the convergence is corrected by aiming the camera horizontally.
3. With a regular wide-angle lens a similar effect is possible. Here, a 20mm lens is aimed horizontally, but the picture is later cropped when making a print.
4. A 400mm lens is used from such a great distance that the camera hardly needs tilting.

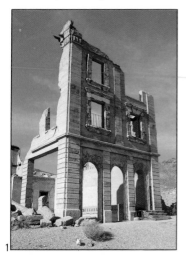

1

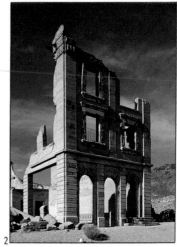

2

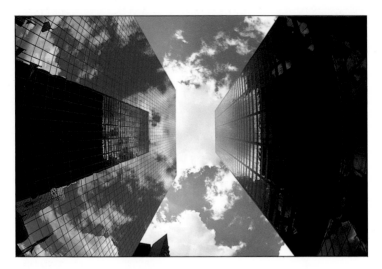

posite directions. This restores the verticals in the picture, although the sides of the print must be cropped.

REVERSING THE PROBLEM: Treat the converging verticals as an interesting graphic element in the image.

Many modern buildings, particularly high-rise office blocks in cities, are so tall and in such crowded surroundings that they only present neck-straining views. These are becoming so familiar that extreme convergence looks less and less odd. Treat this convergence as normal by using a wide-angle lens and an extremely tilted angle. This works better with modern architecture than with classical styles.

ABOVE A carefully aligned vertical view upward relies on extreme convergence for its effect. The angle of view is so exaggerated that the 'correctness' of the angles is no longer an issue. The result is interesting because of its symmetry and because, ironically, flat surfaces are made to curve unnaturally.

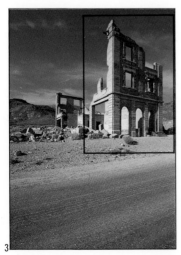

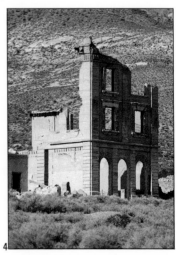

INTERIORS

PROBLEM SUMMARY: Being able to handle lighting is the crucial skill of photographing interiors. Many interior views offer an extreme choice: shooting quickly with existing lighting, or constructing an elaborate lighting pattern with studio lamps.

Interiors present a lighting problem because of the uncertainty and variability of the light sources. Daylight through windows, skylights and doorways, spotlights, striplights, ceiling lights and table lamps may all be mixed, offering a difficult choice of combinations.

Whether or not to add a flash unit or photoflood adds to the number of alternatives. Installing a battery of photographic lights is reliable but a major operation (GO TO PAGES 44-5, INTERIORS/2); the alternative given here is the simplest solution.

DECIDE ON THE MAIN LIGHTING For an efficient result decide which, of all the possible light sources, is to dominate. This decision is the key to simplifying the whole process. The choice is usually between daylight, domestic tungsten lamps, or fluorescent striplights. Having settled on one, choose the film and filter combination to suit.

Use other lights for color effect as desired, but subordinate them to the main light. The simplest way of adjusting the balance between daylight and interior lights is to wait until the level of daylight matches the interior lighting. Installing brighter (that is, higher wattage) bulbs in the fittings will also give you more control. Beware of daylight from a purely blue sky; filtering out the blue cast is neither easy nor certain. On the other hand, precise filtering for domestic tungsten lamps is not usually important.

POSITION THE CAMERA Viewpoint and composition are, in practice, parallel processes, but the light source affects any decision. Don't automatically arrange the light behind the camera - some flare from a facing window is often more atmospheric

BELOW In most interiors, one type of lighting tends to dominate, and is likely to be one of the five listed. As an approximate guide, if you have no accurate method of judging the color temperature, use the filters shown. If the exposure is likely to be very long - half a minute or more - consider using type B film even with daylight, as it shows less color shift from reciprocity failure; if you do this, add an 85B filter.

	SUNNY DAYLIGHT	CLOUDY DAYLIGHT	BLUE SKY	DOMESTIC TUNGSTEN	FLUORESCENT STRIPLIGHT
FILM	DAYLIGHT	DAYLIGHT	DAYLIGHT	TYPE B	DAYLIGHT
FILTERS	NONE	81A	81EF	82B	30 MAGENTA

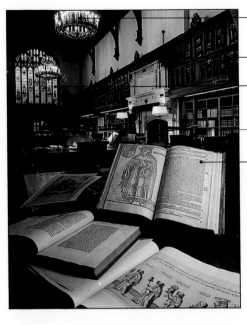

Chandelier as effects light: warm tungsten = about 2700K

Illuminated by mixed natural light/tungsten

Daylight = about 6500K

Illuminated by natural light

Illuminated by reading lamp: warm tungsten = about 2800K

and interesting. (GO TO PAGES 124-7. FLARE.)

Although it is unwise to fall into a standard routine, a wide-angle lens and a position in one corner of the room is a very reliable technique. Interiors tend to look more cramped in a photograph than in real life.

FILL IN THE SHADOWS An uneven pattern of lighting is typical in most interiors, and in a room with one window the exposure spread from one side to another may be about four f-stops. Furniture and fittings also create shadows. Filling in these darker areas is not strictly necessary but it usually helps. Match the fill-in to the main lighting (that is, add flash to daylight or tungsten to tungsten) and keep the fill-in lighting quite mild, or it will cast shadows itself.

SET THE EXPOSURE Read the highlights and the shadows. If the spread is within the range of your film (five stops if transparencies, seven stops if negatives), set the exposure about halfway. If the contrast is greater, consider using fill-in or read the most important part of the room, use that setting and settle for losing some detail. Bracket exposures for safety. Exposures may be so long (one second or more) that the film changes color slightly. Use a tripod and check the instructions packed with the film for long exposures. (GO TO PAGES 120-3, EXPOSURE PROBLEMS.)

ABOVE In the reading room of Washington's Folger Library, a deliberate contrast of color temperature was used to stress the very strong perspective. As the ambient tungsten lighting prevailed, type B film was used unfiltered, so that the small amount of daylight would appear blue. Instead of using balanced photographic lamps for the foreground, a warm-colored desk lamp was placed close, to give a yellowing emphasis to the collection of rare books.

INTERIORS/2

PROBLEM SUMMARY: *Replacing existing lights with your own gives sure control but requires careful positioning, meticulous balance, and several hours of effort.*

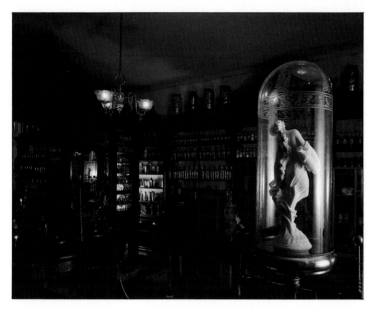

ABOVE In this photograph of a nineteenth-century drugstore, limited lighting was used to convey the atmosphere, which was Victorian and a little fusty, and to give depth by emphasizing the glass-covered statue. The appearance of the glowing central gas lights also adds authenticity. Three 100-watt quartz-halogen lamps were used for lighting, each diffused through square sheets of milky-colored plastic.

Creating the entire lighting for an interior is a major operation, but is painstaking rather than technically difficult. Photographic tungsten lighting is easier to use than flash (you can see what you are doing and long exposures are easier to administer than multiple flashes). The simplest situation is when there is no other light at all. Plan the result from the start, work methodically, and allow plenty of time.

DECIDE ON THE EFFECT YOU WANT Photographic lighting is normally used to imitate natural and ambient lighting. Decide whether the room should appear daylit or artificially lit. For daylighting, place lights outside the window, and cover the outside of the glass with tracing paper. The effect of this, even with the window in shot, is a flood of light that usually looks completely natural. For main indoor lighting, diffusion also usually helps. As a general rule, main lighting from one direction looks the most natural.

REFINE THE LIGHTING PATTERN Unless you want a deliberately stark effect (as in a nightclub, for example), adjust and reposition lights to avoid hard shadow edges, overlapping pools and excessive dark patches. This is often the longest part of setting

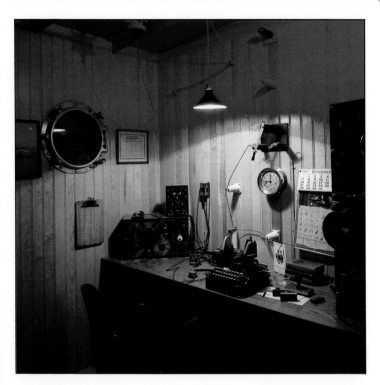

up and also involves moving diffusers, reflectors and flags.

ADD EFFECTS LIGHTS Any light that is included in a photograph for its appearance only is called an effects light. Domestic lamps make good effects lights - they are weaker than photofloods and add warm color.

ADJUST FLARE Black flags, made of stiff card and positioned on a stand, are the simplest way of shading the lens from naked lights. (GO TO PAGES 124-7, FLARE.) A certain controlled flare, however, adds just a touch of imperfection that can be invaluable for a convincing imitation of natural light. Aim the camera towards a strongly backlit window for this effect.

BASIC EQUIPMENT

1. At least five powerful lights, on stands, and spare tubes of one kilowatt each if they are tungsten, or 2,000 joules each if they are flash.

2. Power cables, extensions and connecting leads.

3. Selection of diffusers and reflectors with stands, and flags.

4. Various clamps and camera tape.

5. Variety of spare electrical fittings and fuses.

6. Toolkit and scissors.

ABOVE For realism, it is often better not to fill in every shadow. For this picture of a ship's radio room, a photographic lamp was placed in the existing holder, and a red light was bounced off the top right corner as fill lighting. The resulting arc of light concentrates attention on the instruments and paraphernalia, while the warm, muted overall color creates a secluded atmosphere.

LIGHTNING

PROBLEM SUMMARY: Anticipating the direction and intensity of the next lightning flash makes composition and exposure uncertain. There may also be an element of danger.

Lightning takes its own picture; in theory all that needs to be done is to open the shutter until one or more flashes have struck. In practice, lightning is not reliable, and both composition and exposure call for some guesswork.

ANTICIPATING THE COMPOSITION Most lightning occurs in sequence, and provided that you are at least a few miles away, flashes are likely to strike in more or less the same direction. The cloud base and distance will determine the visible height of the flashes; watch one or two to decide on the focal length of lens.

As lightning storms are generally short-lived, one of the major problems is finding an interesting foreground, which will nearly always appear in silhouette. Move quickly to find a good view.

BELOW A fortunate combination of lightning, fluorescent and tungsten lights provided a striking multicolored effect in this evening scene over the rooftops in Rangoon at the start of the rainy season. Residual daylight was important for the foreground detail, but exposure uncertainty made it essential to take a number of shots at different exposures during half an hour of tropical twilight. This exposure was 30 seconds at f2.8 with a 24mm lens on Kodachrome 64. The lightning was several miles away.

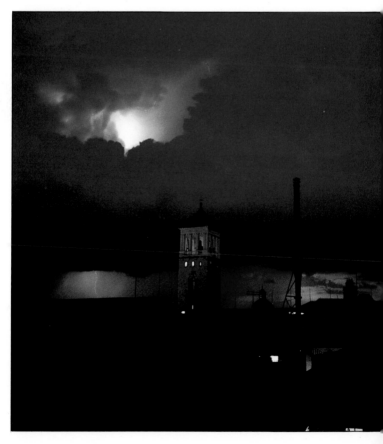

ESTIMATING THE EXPOSURE The exposure is affected by the intensity of each flash (hard to judge), the distance (count the time between lightning and thunder; five seconds equals 1 mile / 1.6km), and the cloud base (if low, the light will reflect strongly). As a rule of thumb, with ASA 64 film, use f11 for less than 2 miles (3km), f5.6 for up to 9 miles (15km), and f4 for over 9 miles (15km), but bracket exposures. Use a tripod and leave the shutter open until you have recorded as many flashes as you want.

There may be a color shift due to reciprocity failure. On Kodachrome 64 this tends towards magenta.

SAFETY A camera on a tripod can attract lightning, so shoot from cover - inside a building or inside a vehicle. Preferably, also shoot from at least 2½ miles (4km) away.

Static electricity in a storm may damage the circuitry in an electronic camera. If you have an exclusively mechanical camera, use that instead.

BELOW Another lengthy tropical electrical storm gave ample opportunity to anticipate a single lightning flash with a long-focus lens, although the camera position did not offer a particularly interesting view of the skyline. Using Kodachrome 64 film and a 180mm lens, the camera setting was 20 seconds at f8 - a full exposure as the low cloud ceiling had the effect of reflecting much of the nearby flash back onto the city. The lightning was about half a mile (0.8km) away.

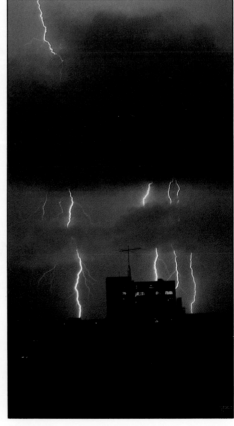

FIREWORKS AND FLAMES

PROBLEM SUMMARY: Fireworks pose similar problems to lightning, and both they and flames are highly variable, making exposure difficult to calculate.

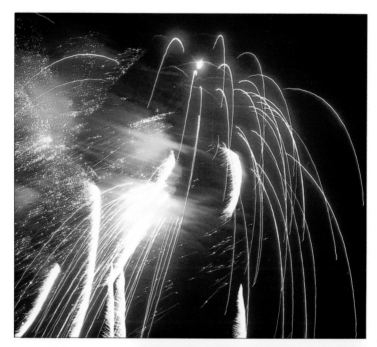

ABOVE Standard technique for firework displays is a time exposure lasting as long as the burst. The exposure setting for this photograph was f4 on ASA 64 film, for five seconds. To fill the picture with the display, a 180mm telephoto lens was used, which increased the risk of poor framing. To counter this, the camera was mounted on a loosened tripod head so that it could be panned to follow the rocket, then the head was locked as soon as the firework burst.

RIGHT For a burn-off at an oil refinery, the exposure was set to match the reading on the through-the-lens meter to give a rich orange color.

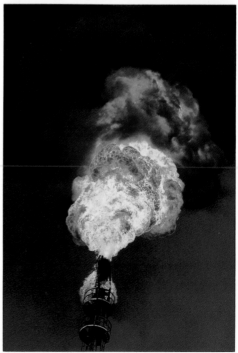

Fireworks and flames are incandescent lighting, very low in color temperature (that is, reddish) and unpredictable in brightness. If they are the subject of the photograph, a slow film and lens with a normal aperture are sufficient. It is possible to correct the reddish color cast by using tungsten-balanced film and a bluish filter, but this is usually unnecessary.

FIREWORKS As with lightning, let a bursting firework make its own exposure by using a tripod and leaving the shutter open. Watch a few fireworks explode to decide on the angle of view and so the focal length of lens.

Most fireworks that burst in the air will explode at about the same height in a display, but for accurate composition, you may be able to follow the rocket in the viewfinder as it ascends, locking the tripod head and pressing the shutter as soon as it starts to explode.

A wide range of exposures is usually acceptable - up to about four stops - but with ASA 64 films use f5.6 as a starting point.

FLAMES If the flame appears large enough in the viewfinder to take a reading, use the meter reading to achieve a rich orange color. If you want to include more details of the surroundings, experiment with more exposure. Use a relatively fast shutter speed (preferably 1/125 second or faster) to keep the shape of the flames sharp. With ASA 64 films, a large roaring fire is likely to need an exposure of about 1/250 second at f2.8, while a candle or oil lamp might need about 1/30 second at f2.8.

BELOW In scenes lit only by a flame, such as this ritual meal within a hill-tribe community, the exposure setting that shows most detail is generally about one stop more than the direct reading of the flame itself. This setting holds detail of the flame but also reveals something of the surroundings.

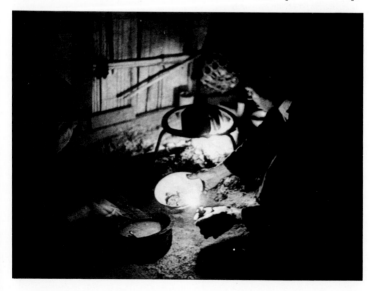

AERIAL VIEWS

PROBLEM SUMMARY: Haze and an inadequate camera position give a poor quality image. In a private aircraft or on a commercial flight, the key is thorough preparation.

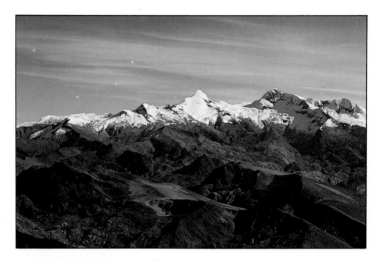

These two photographs, taken of the same Andean peaks within minutes of each other, show how the angle of the sun affects ultraviolet haze. The aircraft circled the mountains at 20,000ft (6,500m). In one picture, the sun was behind the camera, giving a clear view with only a plain glass filter (TOP). In the other, taken from the opposite side of the mountain, backlighting emphasized the haze, giving a blue cast and weaker colors (ABOVE).

Image quality is the main problem with aerial photography. Quality can be maintained perfectly well provided that certain minimum flight and technical conditions are met; in a private light aircraft this is straightforward, but on a commercial flight it may well be impossible.

OVERCOMING HAZE Atmosphere and altitude create low-contrast, hazy, bluish pictures. To correct this, take the following measures:

● **FLY LOW** The less atmosphere between camera and subject, the less haze.

● **USE A WIDE-ANGLE LENS** Haze is less apparent in a wide-angle view.

● **USE A UV OR POLARIZING FILTER** A UV filter cuts down ultraviolet haze, but a polarizing filter is even more effective; rotate it in its mount until the contrast is greatest. Through some aircraft windows, however, it may create an odd multicolored effect.

● **FLY WHEN THE SUN IS LOW** Haze is least noticeable early in the morning and late in the afternoon. The contours of the landscape are also better defined at these times of day.

● **SHOOT AWAY FROM THE SUN** Haze is more apparent facing into the sun; but this may be more interesting.

● **UNDEREXPOSE SLIGHTLY** Reduce the exposure a third or half of a stop to reduce the impression of paleness.

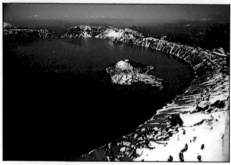

A steep camera angle usually gives more graphic, sometimes abstract, images. Aerial photography provides ample opportunities for such an approach. The nearly horizontal view of Crater Lake, Oregon, conventionally shows the entire setting (LEFT). An almost vertical view excludes the context but makes a more interesting composition (ABOVE). Both examples are good images, but work in different ways.

IMPROVING THE VIEWPOINT Any window, however clean, degrades the image. From a light aircraft, shoot through an open window; in a high-wing model the view will be unrestricted. On a scheduled commercial flight, choose the side of the aircraft that will face away from the sun (reflections and scratches will be less obvious), and choose a seat far from the wings and engines; if possible, also choose a clean window.

The most interesting views are usually looking down rather than across. Take pictures when the aircraft banks towards your side.

AVOIDING CAMERA SHAKE Aircraft vibration can blur photographs. Use as high a shutter speed as possible (preferably 1/500 second), and don't allow the camera to touch the body of the aircraft.

BACKGROUNDS/PEOPLE

PROBLEM SUMMARY: Outdoor backgrounds are often too complicated. Indoor studio backgrounds are frequently dull and boring.

As a rule, the most effective backgrounds are simple and fairly evenly toned, although a texture or pattern adds interest. A long-focus lens often helps to simplify a background, partly by having a narrow angle of view so that it is selective, and partly because its shallow depth of field can throw the background out of focus.

OUTDOOR BACKGROUNDS Unobtrusive backgrounds include any shaded area, such as the interior of a house seen through a doorway, the edge of woodland, grass slopes, the shores of a lake or river from a high viewpoint, an interesting sky (stormy, dawn or dusk), or doorways and window-frames in textured walls.

INDOOR BACKGROUNDS In a domestic interior, walls, windows and curtains are obvious backdrops; remove or add decorations, furniture or props for balance as necessary.

In the studio, seamless paper rolls are so standard that they can be boring. Look for alternative textures and surfaces in upholstery, fabric and hardware stores. Use spray paint to create a precise color or pattern.

RIGHT The most complex of backgrounds for models, when the clothes are all-important, are period furnishings, as used here to complement two Edwardian dresses. Although they are more time-consuming to construct than plain backgrounds using a seamless paper roll, for example, settings such as this establish atmosphere very positively.

For maximum control, and to separate the subject from the background, light the background independently. The most efficient lighting system is a pair of trough-shaped lamps on either side of the backdrop.

The most elaborate background of all is a front-projection system, comprising a highly reflective screen and special on-axis projector; experiment with different transparencies for backgrounds and adjust the studio lighting to match the projected scene.

TYPE	ADVANTAGES	MAINTENANCE	COMMENTS
SEAMLESS PAPER	Heavy-duty, matt, plain background available in 9ft (3m) and 15ft (4.5m) rolls and variety of colors; no join visible	Store on roll; unroll with care so paper hangs free. After use, cut off part that trailed on floor	Prone to creasing. Use slightly out of focus to conceal texture
SPRAY-PAINTED PAPER	Patterns and colors can be created to order: white on blue to suggest clouds	Spray matt paint with aerosol cans on matt paper to avoid reflection. Use seamless paper; avoid creases. Allow to dry before rolling up	Use out of focus to conceal signs of paint and for softer patterns
PLAIN VINYL	Shiny surface that hangs unevenly to give reflections; colors. 'Wet-look' can suit fashion	Reusable; wipe with damp cloth to remove dust and fingerprints	Broadly diffused lighting gives the largest reflections. Best in focus
RIBBED VINYL	High-tech, shiny; available in different colors and textures	Reusable. Roll carefully to avoid creases across ribbing	Use in focus to show ribbing Hang straight
MYLAR	Flexible mirror surface gives distorted reflections; scope for unusual effects	Scratches easily; Shows fingermarks. Not very reusable	Avoid catching reflections of studio lights. Use deep focus for sharp images of distorted reflections
FORMICA FLOORING	Smooth, semi-matt; wide variety of colors and patterns. Sizes large enough for full-length shot. Durable; does not crease	Splinters if bent sharply. Wipe with damp cloth; store upright	Not completely matt, so uneven lighting can show 'hot-spots'
PAINTED FLAT	Flat, free-standing board; permanent and repaintable. Doubles as fill-in reflector	None	Paint to choice with brush or aerosol. Adaptable standard studio fixture
VELVET	Non-reflective cloth gives deep saturated color. Black velvet is the blackest of all backgrounds	Remove lint and dust with tape. Iron on reverse side to remove creases	Appears darker in photographs than to the eye. If draped, looks luxurious, if straight, textureless
TENTING MATERIAL	Rough, stitched and creased texture gives good contrast and a 'behind the scenes' look	None	Tarpaulins and dust sheets are alternatives. Best in focus as a strong element in the picture
FRONT PROJECTION	Any transparency can be used for background. If used skillfully can substitute for real location	Keep screen and transparency spotless. Adjustments and angles are critical	Light subject from same direction as background is lit. Avoid spill of light onto screen. Thin black line may appear around model

BACKGROUNDS/STILL LIFE

PROBLEM SUMMARY: Because still-life photographs are expected to be meticulously composed and precise, the background tends to attract attention and usually needs to be flawless.

The background is nearly always an important element in a still-life image. If badly chosen, the background may overwhelm the image. If chosen well, its texture, color and reflectivity can complement the object, enhancing its appearance. For example, a rough, massive setting, such as a block of stone, can emphasize the delicacy and precision of a piece of chrome metal. When in doubt, the safest choice is a plain background such as white formica or black velvet - uninspired, perhaps, but unobjectionable.

From a low camera angle, avoid a 'horizon' by curving the background upward.

VARYING THE TEXTURE The choice of still-life backgrounds is almost limitless, and sources vary from hardware stores and stationers to rubbish tips (weathered planks and rusted metal have their uses).

CLEANING BACKGROUNDS At close distances, specks of dirt and blemishes show clearly. Wipe off fingermarks and grease, and remove dust and lint with a brush, sticky tape and an antistatic gun.

CREATING BACKGROUNDS WITH LIGHT Pools of light and shadows, if carefully controlled, can add dimension to the shot and can be made to complement the tones of the object so that it stands out clearly.

BELOW Simple backgrounds, relying on textural contrasts and basic associations for their effect, are usually more pleasing than complicated ones. An old stone slab complements its subject texturally and lends a feeling of age and solidity that suits period objects.

TYPE	ADVANTAGES	MAINTENANCE	COMMENTS
WHITE FORMICA	White formica is the standard, unobstrusive background. With diffuse lighting supports objects almost in limbo. Can be bent sufficiently to create a horizonless background. Textureless. Also available patterned	Wash with soap and water. Keep spotlessly clean and free from scratches	A basic fixture in still-life photography
BLACK VELVET	A floating setting for pale and metallic objects. Take care to light the sides of rounded objects, as these can easily disappear into the black	Pick off lint and dust with sticky tape. Brush in one direction	High-quality cotton velvet gives a deeper black than artificial textile
MARBLE	Good for food and some objets d'art. Contrasts well with soft, textured objects, and can add a sense of Mediterranean opulence	Wipe down with damp cloth. Be careful not to drop	Marble-patterned formica is a cheaper substitute, but may not lie perfectly flat and cannot take as high a polish
ROUGH STONE AND SLATE	Best as a contrast for thin, delicate, finely-finished objects, such as jewelry. Matt surface is easy to light	Avoid grease stains. Slate breaks easily	Top/back diffuse lighting makes the most of the textural details. Color deepens if wetted
LEATHER	Good for antique objects and as a contrast for technical and precise objects	Avoid grease stains. Clean with saddle polish. (For suede, use proprietary cleaner and brush in one direction before use)	Use both sides for different textures. Different animal hides give a variety of patterns, colors and textures
MYLAR	Interestingly used for high-tech subjects, illusions, combining swirls of reflected color. Gives unusual distortions but difficult to control	Scratches and marks easily. Wipe very softly. Cannot be used often	Tape in place, as even a small movement alters the reflections completely
PATTERNED OR EMBOSSED PAPER	Many interesting varieties, from metallic finishes to lizard-skin effect	One-time use only, because of creasing and scuffing	Inexpensive and varied
PLEXIGLASS	White plexiglass can be backlit, or lit from underneath. Other colors have clean, sterile look, good for precise and technical subjects	Wipe down regularly with damp clcth. Remove light scratches with polish. Store with paper or card cover	Expensive but looks attractive. Appearance alters depending on whether light source is reflected or not
LIQUIDS	Eye-catching because highly unusual if used as continuous background. As a pattern of drops, adds freshness	Clean by straining through sieve or filter paper	Choose from water, inks, glycerine oil, mercury
CONGLOMERATES	Large quantities of similar objects, such as pebbles or sand grains, have pronounced texture. Can be striking or naturalistic, and good as contrast for smooth subjects	No specific care	Choose from gravel, sand, stones, ball-bearings, pin-heads, table-tennis balls, etc

AVOIDING REFLECTIONS

PROBLEM SUMMARY: Shiny surfaces can cause reflections that interfere with the picture.

A naked, undiffused light creates such a confusing pattern of contrast in highly reflective surfaces that the detail of a design can easily be lost (ABOVE LEFT). Placing opal perspex or tracing paper in front of the lamp broadens the light to give an even, balanced reflection that complements the subject (ABOVE RIGHT).

Surfaces, such as glass, polished metal or water carry reflections of other objects which may not always enhance the picture. This particularly applies to very carefully controlled and deliberately simplified images, such as studio still life; in such miniature set-pieces, any reflection of the surroundings, including camera and studio lights, is an alien intrusion. Reflections can also spoil a photograph by concealment; a painting under glass, the contents of a shop window or fish in a clear pool of water may all be obscured.

CHANGE THE VIEWPOINT The simplest solution is to move the camera so that what is reflected turns out either black or unrecognizable. A large featureless area, such as a clear sky, makes the least noticeable reflection; the darker the better. If there is enough room, a sheet of black paper or a black cloth hung just outside the picture frame is ideal for killing these reflections.

REMOVE THE SURFACE If the reflections are in a glass surface such as a framed print, a watch face or a pair of spectacles, it may be easier to remove the glass temporarily.

POLARIZE THE LIGHT A well-known method of controlling reflections is to use a polarizing filter. Fit the polarizer and rotate it in its mount until the reflections are least. The effect is strongest at about 55°, but with an extreme wide-angle lens, it may work over a part of the image. This technique will not

work for metallic surfaces, however.

Studio lighting is not normally polarized, but by placing sheets of polarizing material over the lights as well as the lens, reflections can be controlled almost completely (but watch out for violet hot-spots in the image).

DULL THE SURFACE Coating the shiny surface with dulling spray (available from professional photographic dealers) or with fine condensation (either by placing the object in the freezer before shooting or by using a freezing aerosol spray) hides reflections. The character of the surface will be changed completely, however.

BROADEN THE LIGHT SOURCE For subjects that are shiny all over, so that some reflections are inevitable, a large diffused light source appears less complicated than several bright lights. In the studio, use a large transparent sheet, such as tracing paper or opal plexiglass, or bounce the light off a white card or wall. Outside, twilight can be ideal, and a cloudy sky is better than sunshine.

CHANGE THE SHAPE OF THE REFLECTION Lights and pieces of cardboard make distracting reflections particularly in the studio. One answer is to alter their shape so that their reflections blend with the shape of the object. For instance, the edges of a white fill-in card could be curved so that they coincide with the outline of a silver bowl when reflected.

TOP The pocket watch on the left is marred by flare: the reflection of the light in the glass. Changing the camera angle or the position of the lamp might alter the image too much; simply removing the glass produces a clear view.
ABOVE Daylight reflections in a shop window can be removed by fitting a polarizer.

57

USING REFLECTIONS

REVERSING THE PROBLEM: Focusing and framing the shot to feature a reflected view can add visual interest, and is also a way of combining images.

Although stray reflections can be annoying, there are also occasions when they can be used to add color or tone to the subject. The art of lighting a reflective object lies in choosing exactly what to mirror in its surface. Shooting from an angle that catches the light brings a sparkle and heightens contrast. Use a wide-angle lens and a small aperture to achieve a star-like effect. Strongly colored objects nearby can also add interest; for the effect of the color alone, use a wide aperture or a long-focus lens (or both) to keep the depth of field shallow, so that the reflection is not sharply focused.

If the surface is mirror-like, the opposite technique - using a wide-angle lens and small aperture to maximize the depth of field - can combine two images. In this case, the reflected image is nearly always more interesting if it appears distorted by the shape of the surface. A very rounded surface, for instance, acts rather like a fish-eye lens and shows a wide field of view, while the slightly uneven surfaces of a large number of windows on the side of an office block can create a rippling image.

There is no need even to rely on found reflections. For tailor-made reflections, use a flexible sheet of mylar (a thin plastic), hold it at an appropriate angle to a subject and shoot into it.

BELOW In this multiple view, the image of a London double-decker bus is repeated in distorted panes of old glass in a church window. The effect is interesting because some panes reflect the image reasonably in focus, despite the wobbliness, while others are excessively blurred.

TOP RIGHT A small reflection of the sun on the giant Buddha was used to emphasize the eye-catching glass mosaics embedded in his nails. A wide-angle lens and a small aperture gave a tiny, star-like reflection, which was caught at its brightest after making tiny adjustments to the camera position.

Flexible mylar gives a simple technique for producing controlled distortion. For a book cover illustration, half of a girl's face needed to be 'stretched' (BELOW). This was achieved by photographing her reflection in a sheet of bent mylar. When working with mylar, it will be discovered that even a small kink or fold in the material stretches or compresses the image very strongly. Because of this, it is worth taping it to a rigid surface such as a sheet of plywood then moving or twisting the pieces of tape to minutely adjust the shape of the mylar and therefore the image (RIGHT). Mylar is difficult to reuse.

CLUTTERED COMPOSITIONS

PROBLEM SUMMARY: Some scenes are so crowded and visually confusing that in photographs they tend to make weak, unmemorable compositions.

Although guides to composition are dangerous (they limit imagination and encourage predictable pictures), in most cases simplicity wins. Certain settings, however, are naturally untidy, making it difficult to compose a simple image. Typically disordered scenes include domestic interiors, workshops, landscapes with dense vegetation, markets and crowds.

Potentially untidy scenes can be organized successsfully with simple photographic techniques. On first sight, this Caribbean beach (BELOW RIGHT) was littered haphazardly with driftwood. Turning the view into a photograph (RIGHT) involved first selecting a focus of interest - a tree trunk. A 20mm wide-angled lens emphasized its stature and also introduced strong diagonal and curved lines to bring structure to the image. The vertical format gave greater prominence to the foreground, and the shot was timed to catch a surge of foam, which captured the liveliness of the scene.

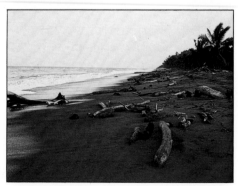

The following are some basic ways of bringing order to a cluttered setting:

- **REARRANGE THE SUBJECT** It may be possible to tidy up an interior or even the foreground of some landscapes, removing some objects from the field of view and laying out others in a neater fashion.
- **USE A WIDE-ANGLE LENS** The image-stretching ability of a wide-angle lens tends to force a graphic unity on a photograph: shoot close to a simple foreground element (such as a row of pots in a market or an isolated rock in a landscape) so that it dominates the composition, providing a strong focus of attention.
- **COMPOSE ECCENTRICALLY** An unusual, eccentric composition can avoid the confusing parts of a scene. A very low horizon line, for instance, eliminates an untidy foreground.
- **COMPOSE IN DISTINCT BLOCKS** If possible, arrange the picture so that there are definite divisions of tone or color. This simplifies the image.

REVERSING THE PROBLEM: Sometimes, a confusing mass of subjects can be framed to create a pattern.

Some subjects that seem disordered from nearby appear regularly massed from a distance and may even begin to look like a pattern. For this to work, the subjects need to be similar - say, a crowd of people, or a mass of cars or boats - and a long-focus lens should be used to compress the image and frame it tightly.

BELOW This scene of decaying tenements crowded with cables, telegraph poles and a mass of unimportant verticals and horizontals, was so cluttered that the confusion itself provided the subject matter. To make the jumble as compact as possible, a 400mm lens was used from an angle, so excluding the sky and the street and compressing all the elements of the photograph.

COMBINING IMAGES

PROBLEM SUMMARY: Bringing together in one photograph subjects from different places or of different sizes calls for a variety of special techniques.

ABOVE LEFT Extremes of focal length can create unusual juxtapositions by showing a perspective that is apparently different from reality. A powerful telephoto lens contrasts the scale of a church tower with a modern office block.

ABOVE RIGHT In the studio shot of a phrenology head, a transparency was projected onto the smooth white surface using an enlarger. A slide projector could have been used, but would not have had the facility to stop down the aperture to accommodate the depth of field.

Juxtaposition is a basic creative technique, not only for balancing a composition, but also for showing or commenting on a relationship between images. Sometimes to make an idea work the picture will rely on subjects that cannot be photographed together in the normal way in one shot: they might be from separate locations or very different in size. If this is the case, one or more special effects techniques will need to be used.

One basic decision to make when combining images is whether or not you want the result to be realistic. Concealing the joining lines and refining the image so that the illusion appears perfect usually involves very painstaking work. One major problem is that if the success of the photograph depends on a flawless illusion, anything less is a total failure. Such perfection is much less important if the images simply need to be brought together, without attempting realism.

EXTREME FOCAL LENGTH It may be possible to overcome size differences by using an extreme wide-angle lens or one with a very long focal length. The wide-angle lens will exaggerate the difference in size in favor of the nearer object, while the long-focus lens will make the further object appear larger. In both cases, use a small aperture for great depth of field (or, with a view camera,

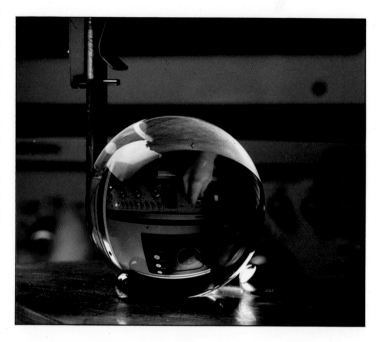

use tilts or swings to keep both objects sharp).

DOUBLE EXPOSURE This is the basic special effects technique, and involves exposing two images on one frame of film or on one enlarged print. (GO TO PAGES 64-5, DOUBLE EXPOSURE.)

SANDWICH A very simple technique is to mount two transparencies or negatives together. For transparencies, each image should consist of a dark subject against a light background; because the sandwich is, in effect, a double thickness of film, each transparency should also be pale (that is, slightly overexposed). By contrast, sandwiched negatives need dark backgrounds and to be underexposed.

REFLECTIONS AND REFRACTION If one of the subjects has a reflective surface, such as glass or chrome, it may be possible to catch the image of the other subject in it. Usually, the depth of field will have to be great, favoring wide-angle lenses. (GO TO PAGES 184-6, RETOUCHING.)

PROJECTION In the studio, a transparency of one image can be projected onto or near another subject. A pale, preferably white, surface, is best. Use a slide projector or an enlarger tilted on its side.

MONTAGE With prints, images can be cut out, stuck together, and rephotographed. (GO TO PAGES 184-6, RETOUCHING.)

ABOVE This perfect quartz sphere was the subject of an experiment. To show it together with the laboratory was a problem because of its small size - only 2in (5cm) in diameter - and the neatest solution was to view the room in the sphere. Minimum aperture was essential for maximum sharpness in a view covering a distance from 8in (20cm) to 5ft (1.5m).

DOUBLE EXPOSURE

PROBLEM SUMMARY: To combine images on the same frame of film, each must be positioned accurately and have a dark background.

One of the most direct ways of combining separate images is by double exposure (multiple exposure if several images are involved). This is a relatively straightforward technique, but the most important rule is that for a good quality image, each subject must be recorded on an *unexposed* area of the film. An uncomplicated double exposure, therefore, needs to have a black background in each of the two images; placing a moon into a night-time view is a typical example.

With more precision, it is possible to create an artificially black background by cutting out a black card mask to the shape of one subject and placing this in front of the lens when shooting another subject. This leaves a black silhouette on the first exposure, into which can be dropped the next image. Although it is an involved and delicate procedure, this masking technique is the basis of all sophisticated combination effects, including photo-composites and dye-transfer strip-ins. It is used more often in the darkroom than in the camera, with masks made of line film rather than cardboard.

The least precise type of double exposure, and so the easiest, is a ghosted image, where the backgrounds are not particularly dark and the two images run into each other. The skill necessary with this technique is in balancing the two exposures and in imagining how the images will fade into each other.

RERUNNING Two images can be combined at different times without holding up other photography.
1. Load a fresh roll and cock the wind-on lever fully. Mark an identifiable position (here the end of a guide rail) by scratching the film.
2. Shoot several frames of the first image, marking a rough sketch on the focusing screen for reference. Alternatively, make the sketch in a notebook.
3. When the film has come to the end, rewind carefully so that the tongue is still showing.
4. At a later time, to shoot the second subject, reload the film so that the original scratch mark is in the same position as before. All subsequent frames will be aligned and the second image can be placed exactly in the frame.

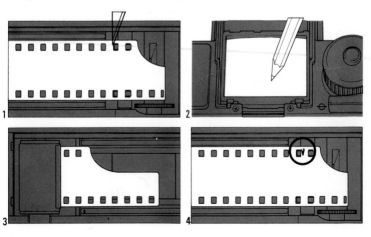

LEFT Elaborate and precise double exposures are best made by copying. The requirement for this book cover illustration was for a pyramid to appear in a suburban setting. The two images - a street of houses and a pyramid (which was in fact a model) - were first photographed separately on 4 x 5in (10.2 x 12.7cm) sheet film. Black line film cut in the shape of the pyramid was sandwiched with the transparency of the houses, placed in the position where the pyramid would eventually appear. Similarly, black line film was sandwiched with the transparency of the pyramid, the only portion cut away being the pyramid itself. These two transparencies, with their silhouette masks, were then copied onto one sheet of film. BELOW The desert landscape with moon was achieved by the fairly straightforward method of rerunning the film. The sand dunes were photographed first; on another occasion, when the moon was full, the second exposure was made.

DIFFICULT LIGHTING

The quality of lighting is more than just an ingredient in photography; it pervades images, creating a particular mood and directing attention. It also influences all the graphic elements, such as color, shape and contrast, and comes in many unusual varieties. Problem lighting could be defined as the type which behaves in a quite unexpected or unlooked-for way.

There is a great temptation in photography to attempt to control all aspects of the image, including light. While in many cases this approach is essential for distinctive and personal pictures, it is not the best way of taking advantage of unexpected, found lighting.

Natural lighting cannot be controlled. You can anticipate it or wait for it to change but, in general, if the sky is overcast when you want sunlight, then you will probably have to make the best of the dull light. Surprisingly, though, many good pictures result from unpromising light. What is possible might actually be better than what was planned.

FLUORESCENT LIGHTING

PROBLEM SUMMARY: Although fluorescent lamps appear white to the eye, on color film they have a greenish cast. Exactly which shade of green, however, is difficult to predict.

THE DISTRIBUTION OF COLORS IN DIFFERENT TYPES OF LIGHT
1. Noon daylight (the norm) shows an even spread of color across the spectrum.
2. Although its name indicates otherwise, when 'common daylight' fluorescent light is photographed, there is a deficiency of red and peaks in blue and yellow. The result is a green cast.
3. 'Cool white' fluorescent light has an even higher peak in yellow, although there is less blue.
4. A few specialist fluorescent lamps made for photography give a close match to daylight. These can be used as replacements for existing fluorescent lighting, but they are expensive.

Fluorescent lamps are increasingly common, because they are efficient and cheap to run. However, unlike daylight or tungsten lamps, they have a 'discontinuous spectrum' - some of the individual colors that make up white daylight are missing. To correct this on film, a filter is needed.

Color temperature is one measure of color accuracy, but even if this is the same as daylight, fluorescent light may still be greenish. The colors on film depend on the make and age of the striplight, so that in theory, if you can examine the lamp, you can choose a filter to suit. In practice, this is difficult and unreliable, and the only certain way of restoring accurate color is to shoot a test roll of film.

TESTING FLUORESCENT LIGHTING Set up the camera for a shot that is as close as possible to the way you will take the real photograph. Use daylight film (fluorescent light is always cool), and if there will be movement, such as people passing, choose a fast film, ASA 200 or ASA 400. Shoot a sequence of bracketed exposures (minus half a stop, normal, plus half a stop) with no filter, then with a Kodak Wratten CC10 Magenta, then 20 Magenta, then 30 Magenta. If you have a special fluorescent-correction filter, also try that. These filters absorb varying amounts of light, so use the camera's through-the-lens meter reading as a starting point. Keep notes so that you can identify the best filter and exposure setting. Develop the film.

FILTERING BY GUESSWORK More often than not, there is insufficient time to test. The next best alternative is to shoot with different filters - 10 Magenta, 20 Magenta and 30 Magenta. If there is time only for one shot, use a 30 Magenta or any of the several proprietary fluorescent-correction filters.

CHANGING THE LAMP Although regularly labeled 'daylight', fluorescent lamps give a distinctly blue-green cast. There are one or two true daylight lamps, expensive but designed for photography. If you can replace existing lamps with these, you can shoot without a filter. Alternatively, buy a sheet of magenta gel of the type used in stage lighting, and wrap it around the existing fluorescent lamps.

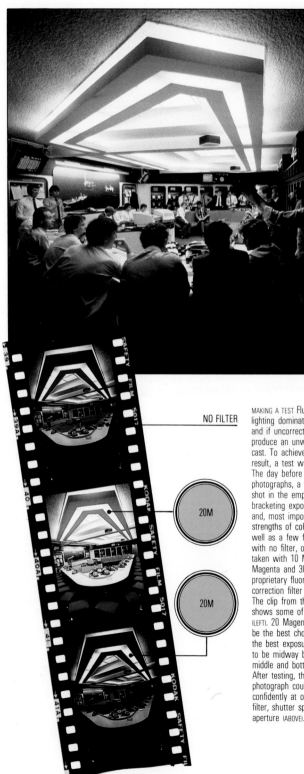

NO FILTER

20M

20M

MAKING A TEST Fluorescent lighting dominates this room, and if uncorrected, would produce an unwelcome green cast. To achieve the right result, a test was essential. The day before taking the final photographs, a test roll was shot in the empty room, bracketing exposure settings and, most important of all, strengths of color filters. As well as a few frames taken with no filter, others were taken with 10 Magenta, 20 Magenta and 30 Magenta. A proprietary fluorescent-correction filter was also used. The clip from the test roll shows some of the differences (LEFT). 20 Magenta appeared to be the best choice of filter and the best exposure was judged to be midway between the middle and bottom frames. After testing, the real photograph could be achieved confidently at one setting of filter, shutter speed and aperture (ABOVE).

FLUORESCENT LIGHTING/2

REVERSING THE PROBLEM: **On occasion, fluorescent light can add a welcome splash of color. On others, its color cast can enhance atmosphere.**

Although white standard daylight is the norm by which other light sources are judged, it does not have to be slavishly reproduced. 'Correct' color is a textbook ideal that ignores the all-important creative effect of a photograph: if a green cast looks attractive to the person behind the camera, that is justification enough for not balancing the color.

OVERALL GREEN CASTS One of the reasons why a generally green image can look acceptable is that often there are no references to suggest that it may be 'wrong'. Many exterior night-time views, such as views of floodlit city buildings and industrial plant, work well when green because of this. Another reason is that the green fluorescent cast is becoming more familiar due to increased exposure.

MULTICOLORED VIEWS With mixed lighting, the contrast of colors can, in itself, be pictorially attractive. Orange tungsten and green fluorescent lights generally combine well (fortunately, because there is no way of balancing both together).

ADDING TO THE ATMOSPHERE The lack of warmth in fluorescent light, and its general associations, can help to make a photograph look seedy or institutional. If you want these connotations, to bring out the atmosphere of a deserted bus depot in the early hours of the morning, the casualty ward of a hospital, or a shabby night-life area, the green cast will usually help.

The colors of fluorescent lighting can add greatly to a picture. Neon displays are designed to be colorful and arresting, and the lamps are tinted so strongly that color correction is impractical as well as irrelevant (FAR RIGHT). The straightforward green cast of fluorescent light adds a welcome splash of color to this night view of Hong Kong's business district (BELOW). In a brightly lit swimming pool, the green fluorescent cast complements the other primary colors of the design (BELOW RIGHT).

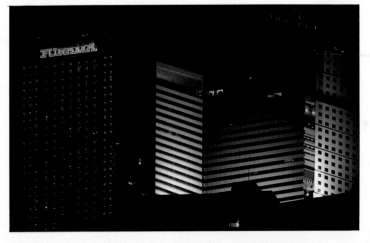

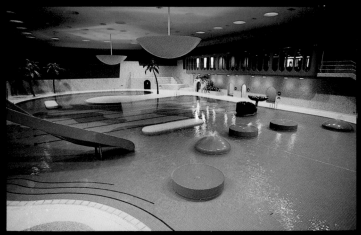

VAPOR LIGHTING

PROBLEM SUMMARY: Most vapor lamps have more extreme color casts than fluorescent lighting - so pronounced that they often cannot be corrected by filters.

In principle, a vapor lamp is a fluorescent lamp without the coating that makes the light appear white. Fortunately, their use tends to be limited to industrial plant and street lighting. The two main types are mercury vapor, which is bluish, and sodium vapor, which is distinctly yellow. In fact, there are so few other colors emit- by these lamps that it is hardly worth trying to use a filter. This is especially true of the yellow sodium lamps used to light streets; a blue filter will simply darken the entire picture without adding any significant amount of blue to the image. In the case of mercury vapor lamps, it may be worth experimen- ting with red and orange filters, but try dif- ferent strengths and do not expect too much. Prior testing, in the same way as for fluorescent lamps, is best. Try to shoot a few test rolls under the same conditions as the final photography will be taken, bracketing exposures and filters.

Generally, the stock advice for color photography by vapor lamps is simply to accept the result. If, however, the shot is important, consider photographing in black-and-white and retouching the print, or even using black-and-white transparen- cy film and then retouching that. (GO TO PAGES 184-6, RETOUCHING.)

Sodium vapor lamps, used here to floodlight an old cathedral, emit light in just one narrow, yellow-green band of the spectrum (LEFT). Adding a blue filter does little to alter the color, and just darkens the image overall (RIGHT). Color correction in these circumstances is not worth attempting.

*REVERSING THE PROBLEM: **The yellows and blues of vapor lighting can be attractive assets in a color image.***

Just as green fluorescent lighting can be attractive in some situations, so can the pronounced color casts of sodium and mercury lamps. The same argument of increasing familiarity is just as relevant here yellow street lighting seems less odd the more often we see it. This is an entirely subjective choice; if you decide that the color cast looks acceptable, it is.

ABOVE The background of this view of the City of London is dominated by the color cast resulting from vapor lighting, here emitted from streetlights. By careful composition, however, the yellow-green is made to complement the deep blue of the Rolls-Royce in the foreground.

TUNGSTEN LIGHTING

PROBLEM SUMMARY: The light from tungsten lamps is orange, sometimes variably so, and often weak. Most tungsten lamps are point sources of light, giving hard, deep shadows..

Tungsten lamps work by burning, and the temperature determines the color - the hotter a lamp burns, the less orange it is. When the lamps are designed specifically for photography, this color rating is carefully adjusted and so is predictable, but ordinary domestic lamps vary. The lower the wattage, the more orange the lamp, and if there are voltage fluctuations, the color will vary further.

BALANCED FILM AND BALANCING FILTERS The two standard ways of correcting the orange cast are by using a film balanced for tungsten lighting (type A or type B) and by using blue color-balancing filters over the lens. Tungsten lamps vary on a scale from red to yellow, so that the same type of filter is always used; only the strength need vary.

These filters combine perfectly with type A or type B film, as well as with daylight film. Use the table as a guide, but for critical certainty with non-photographic lamps, use a color temperature meter or test. (GO TO PAGES 68-71, FLUORESCENT LIGHTING.)

Because most tungsten lighting is much weaker than daylight (in the order of five or seven stops, typically), tungsten-balanced films are generally made to perform best at slow shutter speeds. Daylight color film, however, may suffer a color shift because

Although tungsten light appears much warmer than natural light, oranges and reds are generally acceptable forms of color distortion. Both photographs were taken under the same standard tungsten lamps, on daylight film (LEFT), and type B film. (RIGHT). Despite the lack of correction, the daylight film version is not noticeably odd.

of reciprocity failure at long exposure times; check the information packed with the film, and filter as recommended.

CHANGING THE LAMPS Most tungsten light fittings are similar, so for brighter illumination and a reliable color, it is usually possible to replace domestic lamps with photographic tungsten lamps. Alternatively, you could fit blue-colored lamps if you are using daylight film.

REVERSING THE PROBLEM: Use the redness of tungsten lamps to convey warmth.

For most people, reds and oranges connote warmth. Particularly in the case of firelight and candlelight, uncorrected color can be an asset in a photograph.

ABOVE Naked lights pose the problem of high contrast if they appear in the picture. A simple solution, used in this candlelit photograph of a chess game, is to time the shot so that the actual light is shaded from view. The exposure was half a second at f1.4 on ASA 64 film.

BELOW The redness of tungsten light is variable and the most reliable way of measuring it is with a color temperature meter. Some meters measure the red component of the light against the blue; others take three-way measurements - red, blue and green - and can be used for other artificial light.

LIGHT SOURCES IN INTERIORS	COLOR TEMPERATURE MEASURED IN KELVINS
Candle	1,930K
Domestic tungsten lamp	about 2,900K
Photographic lamp	3,200K
Photoflood lamp	3,400K
Clear flashbulb	3,800K
Direct noon sunlight	5,400K
Blue flashbulb	5,500-6,000K
Daylight: cloudy sky	about 6,000K
Daylight: partly cloudy sky	about 7,500K
Daylight: clear blue sky	over 8,000K

FLASH LIGHTING

PROBLEM SUMMARY: Portable flash units have small heads that inhibit subtle lighting; without an additional modeling lamp the effect of lighting can usually only be guessed.

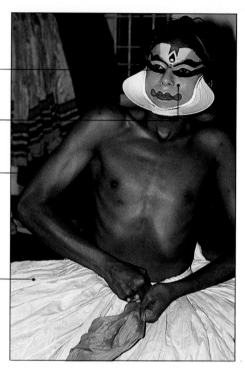

'Red-eye' (reflection from the retina) only appears when the subject looks directly at the camera

Shiny surfaces cause pinpoint reflections. Here, the face paint was not bright enough to cause problems

Backgrounds will be underexposed. Keep them small in the picture

Overexposed whites look terrible, and are not always easy to anticipate. If in doubt, bracket exposures

DANGER POINTS WITH DIRECT FLASH
On-camera flash - a small unit mounted in the hot-shoe - works best with subjects that have a strong simple arrangement of color and tone; the flatness of the lighting is then hardly noticeable. The principal dangers - 'red-eye', reflection, dark background, bleached whites - can be avoided by anticipating the effect of the flash.

Without special attention, flash lighting tends to be stereotyped. The flash tube and its reflector are so small that they cast hard shadows and give pinpoint reflections; the camera's hot-shoe is the easiest place to mount the flash, but the result is a flat, head-on light; a camera-mounted flash also tends to give over-bright foregrounds and dark, featureless backgrounds.

BROADEN THE SOURCE OF LIGHT The simplest ways of changing the quality of flash lighting are either to aim the light through something translucent which will diffuse it, or to bounce it off a bright surface. Both methods make the light source larger. This in turn softens shadow edges and reduces contrast. Although this is standard advice for using portable flash units, softening the light is not necessarily an improvement; it does, however, give you more choice and is efficient, uncomplicated illumination.

MOVE THE FLASH OFF-CAMERA An equally straightforward improvement is to fire the flash at an angle to the camera's view. Use

an extension cable attached to the camera's synchronization terminal, and either hold it at arm's length (overhead and slightly to one side usually works well), or fix it with a clamp or on top of a tripod.

USE MORE THAN ONE FLASH UNIT A second or third flash unit (or even more) increases the lighting choice. Rather than adding them indiscriminately to the lighting set-up, first position one main light; use a second light to fill in shadows; and then place other lights either to illuminate the background or for special effects.

SUBSTITUTE A MODELING LAMP WHEN SETTING UP To gain an idea of the probable effect of the lighting, place a tungsten lamp or a flashlight in the position of the flash unit.

TEST WITH INSTANT FILM The most certain way of checking a flash lighting set-up is to take an instant picture. Use the type of film that will fit into your normal camera or into a substitute back. Remember to adjust the settings for ASA differences if necessary.

REVERSING THE PROBLEM: Strong head-on lighting can enhance some subjects.

A portable flash unit records fine detail well (the light is so small that the shadows are precise) and, when the exposure is correct, it also gives good color saturation (because the lighting is frontal). Subjects that have strong colors and fine texture often benefit from this type of lighting.

77

MIXED LIGHTING

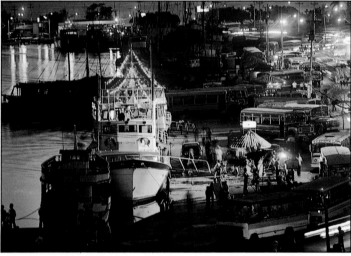

The variety of colors from several different kinds of artificial lamp gives both these images cohesion. In the picture of the Shwe Dagon pagoda in Burma, the composition gives equal weight to the three basic colors, blue (evening sky), gold (tungsten floodlights on the gold stupa) and green (fluorescent and mercury vapour) (TOP).

The South American harbor scene was also photographed at dusk, and the natural light reflects warmly in the water. Many different kinds of lamp built up the illumination, including tungsten, mercury vapor, sodium vapor and colored lamps (ABOVE).

BALANCE FOR:	ADD FILTERS
FLUORESCENT	MAGENTA
SODIUM VAPOR	CAN'T EFFECTIVELY FILTER
MERCURY VAPOR	RED
TUNGSTEN	BLUE

Tungsten, fluorescent and vapor lights are often found all together in one scene. The result, naturally, is multicolored, but applying filters to balance one of the light sources usually exaggerates the color cast of the others.

The adjustments made for one of the light sources will always be wrong for the remainder, so the first decision should be to decide which lighting is the most important. Normally, this will be whichever one dominates the scene, but sometimes the important light is the one that illuminates something that has to look right, even it occupies a small proportion of the picture. The skin tones of a face, for example, usually look wrong if lit by colored light, especially if it is greenish or bluish. If no one light source is more important than the others, make no adjustments.

REVERSING THE PROBLEM: Use mixed lighting for its multicolored effect.

A scene lit by, say, sodium vapor, fluorescent strips and tungsten lamps is at least colorful. On occasions when the precise color of any of the subjects is not important, the effect can be attractive, and if the composition of the scene lacks vitality, the colors can help to make it work as a photograph. Most lighting problems are best solved by following personal taste rather than textbook rules.

| EFFECT ON OTHER SOURCES | | | | |
FLUORESCENT	SODIUM VAPOR	MERCURY VAPOR	TUNGSTEN	DAYLIGHT OR FLASH
WHITE	NO EFFECT	SLIGHTLY WHITE	RED	PINK
WARM WHITE	NO EFFECT	WHITE	RED	PINK
BLUE/GREEN	NO EFFECT	BLUE	WHITE	BLUE

NIGHT

PROBLEM SUMMARY: Night scenes are generally lit dimly and unevenly, with pools of light and point sources that can cause flare. At night, it is also difficult to see the camera controls.

Night photography involves using moonlight, starlight or artificial light sources. The main problem is to decide when setting out

HANDHELD/AVAILABLE LIGHT To photograph movement in depth and remain inconspicuous, use a high-speed film (ASA 400 or faster), a fast lens (f1.4 or f1.2) and moderately slow shutter speeds (1/15 second to 1/60 second). Best for: candid shots, active street scenes, shows and restaurants.

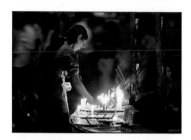

HANDHELD/FLASH For a sharp picture of fast-moving subjects, use a medium to slow film (ASA 50 to ASA 100) and portable flash. Best for: people (but not candid photography), and any fast, close action.

TIME-EXPOSURES For motionless subjects, use a medium to slow film (ASA 50 to ASA 100), a tripod, cable release, and filters to correct reciprocity failure (see instructions packed with the film). Best for: landscapes, cityscapes and interiors without people.

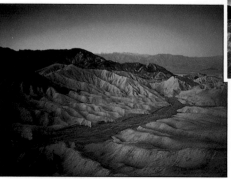

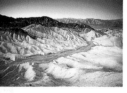

The daylight view (ABOVE) was converted into a simulated night-time image (LEFT) by using a blue 80B filter, a neutral graduated filter to darken the sky, and underexposing by two stops.

which of the basic techniques to use: hand-held with fast film and a fast lens, handheld flash with slow- or medium-speed film, or tripod with slow- or medium-speed film and time-exposures.

CAMERA CONTROLS IN THE DARK Cameras with LED meter displays are the easiest to use, otherwise carry a penlight. In any case, apertures and shutter speeds are marked by click-stops: turn the ring from one end to set the exposure.

Focusing in darkness is less easy. A large microprism grid in the viewing screen may help, or training a flashlight or car headlights on the subject. If this is impractical, focus on something brighter that seems to be the same distance away - points of light are easiest.

REVERSING THE PROBLEM: Instead of trying to overcome darkness, use it for dramatic effect.

Only convention decrees that the details of night scenes should be perfectly visible. Landscapes in particular can look exciting in semi-darkness. Try underexposing by one or more stops for a realistic rather than a 'corrected' effect.

DAY FOR NIGHT A long-standing technique of motion picture work is to shoot a scene in daylight so that it appears as if it were night.

● **MAKE THE SKY AS DARK AS POSSIBLE** For black-and-white film, a red filter and polarizer, together with high-contrast printing, can make a blue sky nearly black (infrared film is even more effective). For color, try a combination of polarizer and dark grey graduated filter.

● **KEEP THE WHOLE PICTURE DARK** Underexpose by around two stops.

● **USE SILHOUETTES** Our night-time vision senses shapes and outlines better than details, and many objects in darkness appear as silhouettes: use backlighting where appropriate.

● **CONSIDER ADDING A BLUE CAST** Night scenes are never actually blue, but many people imagine them to be (GO TO PAGES 84-5, MOONLIGHT AND STARLIGHT). As day-for-night photography is a type of illusion, a blue filter (such as a Wratten 80B) may help.

● **ADD STARS AND MOON LATER** For a complete illusion, use double exposure to create a night sky (GO TO PAGES 64-5, DOUBLE EXPOSURE).

Always bracket exposures, but use these settings as starting points:

NEON DISPLAY

ASA 400:
1/30 second f5.6

ASA 64:
1/30 second f2.8

BRIGHTLY LIT STREET

ASA 400:
1/60 second f2.8

ASA 64:
1/15 second f2.8

FAIRGROUND

ASA 400:
1/60 second f2

ASA 64:
1/8 second f2.8

FLOODLIT BUILDING

ASA 400:
1/30 f1.4

ASA 64:
1/2 second f2.8

NORMALLY LIT STREET

ASA 400:
1/15 second f1.4

ASA 64:
1 second f2.8

DISTANT CITY LIGHTS

ASA 400:
1/15-1/2 second f1.4

ASA 64:
1-10 seconds f2.8

OVERCAST WEATHER

PROBLEM SUMMARY: *Continuous cloud cover gives flat lighting without the shadows and highlights that accentuate shape, and at the same time creates high contrast between ground and sky.*

ABOVE The upper pair of photographs is a practical demonstration of how overcast weather can improve some scenes. Taken on consecutive days in Death Valley, California, they show how a complex subject is simplified by soft shadows. A warming filter was used for the overcast picture. The lower pair of photographs show how a common problem - skies appearing brighter than the ground - can be solved by using a neutral, graduated filter.

Grey days lack contrast and variety. The lighting is the same whatever the direction of shooting, and often lends a distinct feeling of dullness to a scene. When the photography cannot wait for brighter weather, there are a few remedial measures.

USE A GRADUATED FILTER A neutral - that is, grey - graduated filter is probably the most useful accessory on cloudy days, certainly for landscapes and other broad views. Use it to darken a sky.

The best design is one which can be adjusted up and down, and rotated in front of the lens; position it so that the soft edge of the dark area lines up with the horizon. This edge appears sharpest through a wide-angle lens and at small apertures, and may sometimes appear *too* sharp to be natural; on the other hand, the edge becomes too vague to be useful with a long-focus lens.

USE A SKYLIGHT FILTER TO WARM COLORS Because cloud cover filters a mixture of sunlight and blue sky, the result is usually slightly cold. A mild color-balancing filter, such as 81A, usually helps.

BRIGHTEN CLOSE SUBJECTS WITH FLASH Use portable flash on subjects within a few yards, but to avoid an artificial appearance, keep the flash output lower than normal, and keep the shutter speed slow enough for the natural lighting to register normally.

PUSH THE FILM TO INCREASE CONTRAST Increasing development raises contrast, although doing this by more than one stop can also harm the quality of the image (making it grainier and weakening blacks). When shooting, underexpose to compensate for push-processing, which you can do yourself by increasing the development time, temperature, or solution strength; alternatively, instruct the lab.

REVERSING THE PROBLEM: Being diffused and shadowless, overcast light might be better for some subjects, particularly those with complex shapes.

Many people would choose bright sunshine as the best lighting for a scene, but this preference is often based not on its appearance but on expectations and associations - sunshine means warmth and fine weather. Bright, strong sunlight actually makes some subjects hard to see, casting sharp shadows that confuse the shape.

Diffused light helps to reveal details in subjects that have strong relief or complex shapes. Cloudy days or twilight also provide useful conditions for clear views of shiny subjects such as cars; the even-toned sky gives broad, uncomplicated reflections (GO TO PAGES 80-1, NIGHT).

ABOVE The complex and detailed structure of an old oak forest would have appeared hopelessly confusing under a bright sun. The soft light from a thin, cloudy sky allows the texture of the vegetation to come through clearly.

MOONLIGHT AND STARLIGHT

PROBLEM SUMMARY: Natural lighting at night is extremely weak, calling for very long exposures and adjustments for reciprocity failure.

ABOVE By photographing a nighttime landscape in partial silhouette against the moon, the exposure could be much shorter than if full detail were needed. Mist diffused the moonlight, reducing contrast. The exposure, with a 180mm lens, was four seconds.

Landscapes under a night sky can make unusual and dramatic photographs, sufficiently so to make the technical problems worthwhile. Human vision is more sensitive than film, but if you can see most of the features in a night scene, there is probably enough light for photography. (Wait about 20 minutes after leaving a brightly lit interior to adjust to full night vision.)

A full moon in a clear sky is the best condition for such photography, but, even so, the moon is about 400,000 times *less* bright than the sun. Other phases of the moon are proportionately dimmer, and even thin cloud will cut down the light by another one or two stops. When only stars or a thin crescent moon are visible, shoot just before dawn or in the late dusk.

BALANCING COLOR Moonlight, which is nothing more than reflected sunlight, is white, so in theory a moonlit landscape should appear in its natural color in a photograph. In practice, long exposures cause color shifts in many films and a greenish cast is typical. Check the information packed with the film and use the filter recommended. The instruction leaflet may advise against extremely long exposures of a minute or more; ignore this, but take a note of the filter color suggested for the longest recommended exposure - you are likely to need the same color, but higher strength, filter at exposures of several

minutes, to prevent the greenish cast.

ESTIMATING EXPOSURE Reciprocity failure, which causes color shifts in color film, also makes films less sensitive at long exposures. Under moonlit conditions, you may need to leave the shutter open perhaps three or four times longer than you might expect. Up to a point, the information sheet packed with the film can be used as a guide; but beyond that, in the same way as for color balancing, bracket exposures very generously. For example, with ASA 64 film such as Kodachrome, typical full moon exposures are, at f2.8, between 15 minutes and two hours; with ASA 400 film such as Ektachrome, the equivalent times should be between one and 10 minutes. Use a wide aperture to keep exposures as short as possible; with a long-focus lens, however, there is then a danger that foregrounds may be out of focus - and it might be too dark for you to notice at the time.

STAR STREAKS At exposures over about one minute, stars appear as short streaks instead of points, because of the earth's rotation. Exposures of some hours produce long curved streaks that make circles around the Pole Star (in the northern hemisphere) or Southern Cross (in the southern). Similarly, the moon appears lozenge-shaped instead of round at exposures of more than several seconds.

ABOVE A three-minute exposure with a standard focal length just begins to show the rotation of the earth by recording the stars as short streaks. A much longer exposure would show these streaks as curving lines. The woman's silhouette in a lit interior confirms the impression of darkness.

HAZE

Problem Summary: Over a distance, haze reduces clarity and weakens an image; on color film it adds a blue cast.

Atmosphere scatters light and the light that has been scattered, instead of helping to form an image, softens the view and makes details harder to see. Known as haze, this effect is greatest over a distance, and when there is water vapor in the air (on muggy days) or fine dust.

The short wavelengths of light (blue, violet and ultraviolet) are scattered more than other colors - on color film, haze consequently appears bluish. Because film is sensitive to some ultraviolet, which is invisible, the effect is more pronounced in a photograph than it appears at the time.

REDUCING HAZE

● **USE AN ULTRAVIOLET FILTER** A clear glass filter reduces the ultraviolet component of haze; if tinged yellow, it reduces blue overall. With black-and-white film, use an orange or red filter.

● **USE A POLARIZER** Over a distance, and used at right-angles to the sun, a polarizing filter can be spectacularly effective.

● **USE A WIDE-ANGLE LENS** Although a wide-angle lens does not actually cut haze, in normal use it shows less because a typical view includes so much foreground.

● **MOVE CLOSER** The less atmosphere between camera and subject, the less haze.

● **SHOOT AWAY FROM THE SUN** Backlighting causes the most scattering. Keep the sun behind the camera, or to one side. There is less haze very early and very late in the day.

When circumstances allow, the most spectacular improvement to a hazy scene can be achieved by using a polarizing filter, provided that the sun is more or less at right-angles to the view, as it is in this pair of photographs. The normal, unfiltered image (LEFT) is given more contrast and good color saturation by a polarizer (RIGHT). Rotate it in its mount until the effect appears strongest.

REVERSING THE PROBLEM: Use haze to give depth to a landscape, to separate close objects from those in the distance, and for its color.

Ruthlessly eliminating haze makes a view crisper, but it can also flatten the perspective. For softer, more atmospheric and deeper views, keep or accentuate the haze by reversing the techniques suggested for reducing haze.

Strong backlit haze can produce striking graphic images made up of distinct planes, particularly in hilly or mountainous scenes where there is a succession of ridges. At sunrise and sunset, haze converts red (on rocks and clouds, for instance) into magenta.

ABOVE One of the strong graphic elements in this photograph of an old flooded forest is the clear separation between the skeleton outline of the trees and the distant mountain. Strong haze gives subtlety of color and enhances the depth of the scene.

FOG AND MIST

PROBLEM SUMMARY: Like haze, but more extreme in their effects, fog and mist weaken the image and desaturate colors. They can also obscure parts of the view completely.

Although the problem presented by fog and mist is similar in principle to that of haze, there is no real solution if detail and color is required. While haze is caused by selective scattering and so can be filtered, the water droplets in fog and mist are so big that they can scatter all the wavelengths of light. Only by shooting very close is a clear view possible; use a wide-angle lens to improve the coverage.

Both fog and mist are usually short-lived; the best answer is usually to wait until they have dissipated and the conditions have improved.

REVERSING THE PROBLEM: Fog and mist can simplify an image like no other lighting conditions, creating silhouettes and eliminating backgrounds.

Fog and mist are often great pictorial assets and present opportunities too valuable to miss. Although occasionally they interfere with planned shooting, more often they create unexpected and quite effective photographs.

Fog and mist separate objects from their surroundings, such as individual trees in a forest. Shapes dominate; subjects with interesting outlines benefit particularly. Colors are heavily muted - monochromatic views can make a useful change from bright, multicolored pictures of the same scene. Foggy scenes often have associa-

BELOW Although fog and mist have a strong diffusing effect, the lighting can still be directional when the sun is low in the early morning and late afternoon. Shooting toward the sunlight creates simple, definite silhouettes, while mist still shrouds a river bank early on a summer morning.

tions of silence and isolation and are useful for creating this type of mood.

CREATING FOG AND MIST Because they are so unpredictable, these weather conditions can never be relied on for photography. When they are needed, it may be best to create them artificially. On a large scale, use an oil-burning fog-maker of the type designed for motion picture work - these machines can usually be hired. For work on a small scale, preferably indoors, use a bee-gun that contains a mixture of burning charcoal and incense. Alternatively place dry ice in a bucket of warm water. This produces a ground-hugging layer of mist that quickly dissipates. Less elaborate is a fog filter.

ABOVE Fog reduces the number of elements in a picture, making clear compositional structures easier to achieve. In this rural scene in southern India, the background has disappeared except for the simple vertical of one palm tree and the vague outline of the bank. These shapes echo the structural lines in the foreground, while the muted tones enhance the contrasting skin and tee-shirt.

RAIN

PROBLEM SUMMARY: Apart from wetting cameras, rain has the same effect in photography as mist. Light levels are usually very low.

ABOVE Dull light and subdued colors, the effect of rainy weather, can reinforce the atmosphere of a scene. Here, the uniform grey tone caused by rain sweeping across this hillside in the New Territories near Hong Kong, enhances the solemnity of the occasion as a woman tends a family grave.

Rainfall is less visible in a photograph than to the eye. At the range of shutter speeds that rainy weather allows (normally less than 1/125 second), raindrops appear at best as streaks and more often as a mist-like veil. For better color saturation and more detail, shoot from as close as possible. Underexposing and then pushing development by half a stop or one stop will improve contrast slightly. Because most rain falls from thick cloud, lighting is usually dim. For active subjects use high-speed film. (GO TO PAGES 88-9, FOG AND MIST.)

PROTECTING THE CAMERA In light rain, a hooded raincap or an umbrella tucked into the shoulder is adequate protection. In heavy rain, waterproof the equipment. (GO TO PAGES 132-3, WATER.)

REVERSING THE PROBLEM: Treat rain as a subject.

Rain and poorly lit days are seldom photographed and are usually considered hostile to photography. For this reason, these situations provide a relatively fresh source of pictures. Rain makes an in-

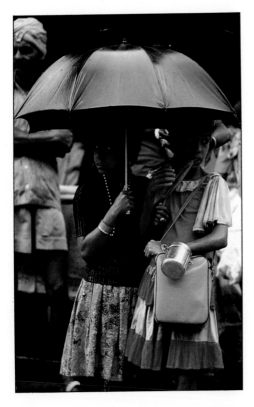

teresting subject in itself and in the effect it has on people, animals and the landscape. Look for and focus on subjects such as umbrellas, people hurrying for shelter, raindrops on windscreens and other surfaces, animals taking cover, water dripping from leaves, and so on. Because falling rain is very difficult to capture on film, it is a good idea to make one of the rain 'symbols' prominent in the picture.

CATCHING THE IMAGE OF RAIN To register clearly on film, rain needs to be both backlit and seen against a fairly dark background. Understandably rare, the ideal occasion is when a break appears in rainclouds to allow a shaft of sunlight through. Imitating this with flash rarely works well, as the rain cannot be lit evenly in depth.

CREATING RAIN Only attempt this on a small scale (with a background only a few feet away), as there is no way of creating the impression of depth of rainfall in a landscape. For close subjects, use any form of sprinkler system (adapting a garden sprinkler is relatively simple), and make sure that everything is wetted.

SNOW

PROBLEM SUMMARY: Falling snow has most of the problems of rain; fallen snow poses only one real difficulty - correct exposure.

SNOWFALL Just as rain falls too fast to appear sharp on normal film under most conditions, so snowflakes usually appear as a misty blur. As the flakes are white and relatively dense, distant views seem to be covered with a white fog, while snowflakes very close to the camera give a dappled effect.

Light levels are usually low in winter conditions - thick clouds and a low sun - and exposures of around 1/60 second at f2.8 on ASA 64 film are typical. Fast film may be necessary.

Even more than rain, falling snow drains color from a scene, making photographs look monochromatic. If this seems a problem, include a brightly colored object in the foreground of the picture.

SNOW-COVERED SCENES Fallen snow is the one weather condition that completely alters the appearance of the landscape, and is so reflective that it can reverse the normal situation of bright sky/dark land. Under an overcast sky, contrast is lower than average, but in bright sunshine, and especially with backlighting, contrast is higher. (GO TO PAGES 94-5, HIGH-CONTRAST LIGHT; 120-3, EXPOSURE PROBLEMS)

In either case, if snow more or less fills the scene, accurate exposure readings can be difficult. Any meter will simply show how to record it as grey, not white, so that if the meter is pointed directly at snow, remember to increase the exposure setting shown by between one or two stops. (GO TO PAGES 120-3, EXPOSURE PROBLEMS.)

RIGHT Under a cloudy winter sky, light levels are low, despite the high degree of reflectivity of snow. To achieve a light image given such conditions, allow one stop more than the meter reading. Contrast will be low and there is usually a bluish color cast. The photograph was taken on ASA 64 film, with an exposure of 1/30 second at f5.6.

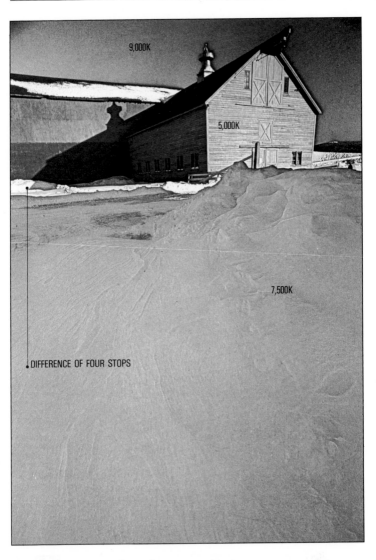

9,000K

5,000K

7,500K

DIFFERENCE OF FOUR STOPS

Bracket exposures by at least one stop to be certain of accuracy; if only slightly too dark, snow appears dirty, while if just a little too light it can appear bleached out.

Like any reflector, snow picks up color from its surroundings and from the sky on a clear day. To the eye, snow in open shade may not seem to have any particular color, but it can turn out a strong blue on color film. In a wider view this is not likely to be a problem, but it can be if you are photographing an entirely shaded view. As a rule, try not to concentrate solely on shaded areas, but an amber color-balancing filter, about the strength of Wratten 81D or 81EF, should neutralize the blue.

ABOVE In bright sunshine, snow scenes are quite different. Contrast is high - a difference of up to four stops between sunlit snowdrifts and those in the shade, while the intense blue sky of a crisp winter day is picked up faithfully by snow lying in shadow. On slide film, it is essential to preserve detail in the highlights; here the exposure was two stops lighter than a direct meter reading off the sunlit snow. The exposure, on ASA 64 film, was 1/125 second at f11.

HIGH-CONTRAST LIGHT

PROBLEM SUMMARY: Dry, clear air and a bright sun help create too much contrast for most films.

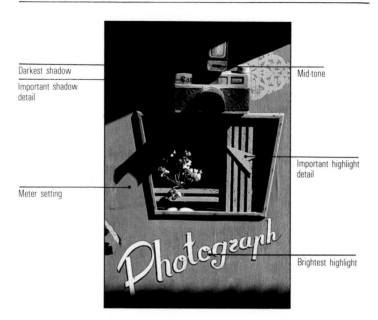

Darkest shadow

Important shadow detail

Meter setting

Mid-tone

Important highlight detail

Brightest highlight

ABOVE In this starkly lit view of a portrait photographer's booth in Burma, the contrast range covered eight stops; that is, the shadow at the top was eight times darker than the white paint of the sign. Neither a typical negative film with a latitude of seven stops, nor slide film with a latitude of five stops, could record detail everywhere. As highlight details were considered more important than the shadows in this photograph, the exposure was based on the light brown wood, not on the mid-tone.

High contrast is caused by stark lighting, unsoftened by clouds or haze. Deserts (which have dry air) and mountains (where there is less air) are the prime locations for high-contrast light, but it is also associated with the fine weather which comes with high pressure systems.

Although there is some variation between types, most color transparency films have a contrast range of only five stops, and most negative films seven stops. In other words, a typical color slide can record all the details in a scene in which the highlights are five times brighter than the shadows. Intense sunlight, however, can easily create highlights nine or 10 times brighter than the shadows in a landscape.

Usually, something has to be sacrificed -either highlight detail or shadow detail. Simply averaging the exposure between the two does no good. The following are some ways of dealing with high contrast:

● EXPOSE FOR THE IMPORTANT DETAILS Decide what aspects of the scene you need to record, and what would look wrong if under- or overexposed. In transparencies, overexposure (such as bleached-out skies) nearly always looks bad.

● COMPOSE TO AVOID HEAVY SHADOWS Choose a viewpoint and composition that

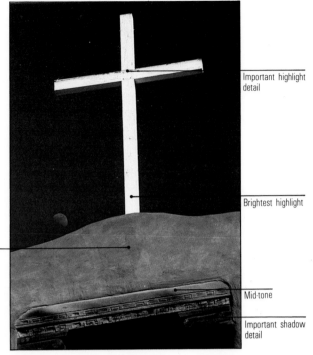

Important highlight detail

Brightest highlight

Meter setting (slide film)

Mid-tone

Important shadow detail

keeps the shadow areas small. Even if they are too dark, it will not really matter.

● SHOOT AT A DIFFERENT TIME OF DAY Depending on the subject, the angle of the sun may make a difference to the contrast.

● USE FILL-IN FLASH A small dose of flash can lighten shadows without looking artificial. Set the output for about a quarter of what it would need to be for full lighting. Alternatively, on a small scale, use a reflector such as white cardboard or crumpled foil.

● USE LOWER-CONTRAST FILM Some films (such as dye-image black-and-white) have less contrast than others. Reducing the development also lowers contrast.

● USE A GRADUATED FILTER If the scene is divided quite clearly into a dark and a bright area, fit a grey graduated filter .

REVERSING THE PROBLEM: Extreme contrast can make exciting, graphic images, given the right choice of subject.

High-contrast lighting may be a problem if you want detail and realism, but it is perfect for abstract images, where line and shape are more important than content. The best subjects for high-contrast treatment are therefore the ones with simple shapes and surfaces.

ABOVE The clear spring air in New Mexico gave rise to conditions of contrast, although slightly more muted than the Burmese picture. The range, from the white cross to the shaded doorway, covered seven stops. Negative film could just record detail everywhere, so that the best exposure setting would be for the mid-tone marked. Slide film, however, would lose detail somewhere; to preserve details in the white paintwork, the exposure setting was set not for the mid-tone but for the adobe wall, which was two stops darker than the cross.

TROPICAL LIGHT

PROBLEM SUMMARY: For most of the day in the tropics, the sun is high and gives unattractive light. It also rises and sets quickly, allowing little time for photography.

In the tropics, the midday sun is nearly, sometimes exactly, overhead. If you live further north or south, in the middle latitudes, this light will seem unfamiliar and not particularly pleasing. By about 9.00 am, just three hours after sunrise, an equatorial sun is as high as it ever gets in, say, London or New York.

Everywhere light will be at right-angles to the camera and with subjects that are basically horizontal, such as most landscapes, will cast no obvious shadows. The shadows of taller subjects, like buildings and people, will be cast directly underneath them.

The amount of contrast varies a great deal, from very little in a panoramic view of a landscape, to high contrast around streets and buildings. Exposure settings may cause some problems because, although the sun is as bright as it can be within about a couple of hours of sunrise and sunset, it seems as if the light should get stronger as the sun rises higher. It doesn't, so rely on the meter. (GO TO PAGES 120-3, EXPOSURE PROBLEMS.)

SHOOT EARLY AND LATE - AND QUICKLY The most effective answer to tropical light is to take photographs when the sun is low, and avoid any time between mid-morning and mid-afternoon. In principle, this works well, but as the sun rises and sets almost vertically, it appears to move very quickly indeed. For low-angled lighting, you may find that you have less than one hour at each end of the day. A basic precaution, then, is to make all the preparations that you can beforehand - such as getting into

RIGHT Using the warmth and variety of light from a low sun is as easy as in other climates, and a tropical sun is often more reliable. This useful time of day is, however, short-lived. Concentrate effort in the early morning and late afternoon; the powerful midday sun can overwhelm the beauty and variety of subjects in these climes, and remove the feeling for form.

position and setting up the camera for a landscape shot.

In many parts of the tropics, late afternoon is a time for short violent storms, which may ruin a planned shot but can be marvelous for dramatic lighting. Lighting conditions are completely unpredictable, so be ready to react quickly.

SHOOT PORTRAITS IN OPEN SHADE An overhead spotlight, which is how a tropical sun appears, has an odd effect on faces, lighting foreheads and noses, but casting eyes and lower cheeks into shadow. If you are taking portraits by natural light, shade is more flattering. By positioning your subject close to a sunlit wall, the reflection becomes a pleasantly diffused main source of light.

REVERSING THE PROBLEM: Though not conventionally pictorial, midday tropical light gives a good impression of heat.

One of the qualities usually missing from carefully lit photographs taken in the tropics is the feeling of intense heat - a factor that may be often overwhelming at the time. Starkly lit views, with vertical shadows, however, convey this perfectly.

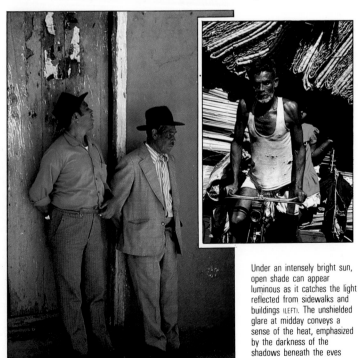

Under an intensely bright sun, open shade can appear luminous as it catches the light reflected from sidewalks and buildings (LEFT). The unshielded glare at midday conveys a sense of the heat, emphasized by the darkness of the shadows beneath the eves (ABOVE).

MOUNTAIN LIGHT

PROBLEM SUMMARY: *Because the air is thinner on mountains, sunlight is high in contrast; there is also strong ultraviolet scattering, giving a blue cast to color photographs.*

Mountain views can be exceptionally crisp and clear, which is good for sharp, detailed photographs, but there are also some disadvantages. One of these is high contrast, particularly in subjects close to the camera; at heights of more than about 10,000 ft (3,000m), shadows look black and show up as inky and lacking in detail on ordinary films that cannot record the extreme contrast. (GO TO PAGES 94-5, HIGH-CONTRAST LIGHT.)

A second problem is ultraviolet scattering. Although ordinary atmospheric haze diminishes with altitude, there is more ultraviolet because the thinner air screens less from the sun. As regular film is particularly sensitive to these shorter wavelengths, distant scenes appear blue (pale in black-and-white).

In the shade, in clear weather, the light is blue for a slightly different reason - light in thinner air is a more intense color than at sea-level. If possible, avoid taking pictures in shade at altitude, or use a fairly strong orange filter such as a Wratten 85. (Without a color temperature meter, judging the exact strength is difficult.)

Mountain weather is not always fine and bright, but cloudy days pose no more problems here than they do lower down, except for a slight overall blueness that can be cured with Wratten 81B filter. One special condition, however, is being in the middle of cloud; visually, this is identical to fog. (GO TO PAGES 88-9, FOG AND MIST.) Generally, mountain weather is very changeable, so don't plan on conditions more than half an hour or an hour ahead.

REVERSING THE PROBLEM: *Early and late in the day, mountain light can be the most spectacular of all.*

Despite all the difficulties during the day, a rising or setting sun in high mountains can provide marvelous, short-lived moments, when the tip of an ice peak glows bright gold or the lines of gullies and ridges are etched by cross-lighting, for example. High, obvious vantage points are nearly always the best places to visit at sunrise and sunset.

FAR RIGHT These two photographs show the extent to which mountain light can vary, even in the same general location and at similar altitudes. The picture of the Cascades in northwestern United States was taken at midday, toward the sun, from an aircraft at some distance away - the most extreme conditions for blue ultraviolet haze (ABOVE). In the photograph of the nearby mountains of Glacier National Park, the sun is lower and more behind the camera. A wide-angled lens includes more foreground through less atmosphere and a polarizing filter cuts the haze even further. The result is a crisper view and rich colors (BELOW). Although the lighting is different in each photograph, neither picture is more 'correct' than the other. Each has its own visual appeal.

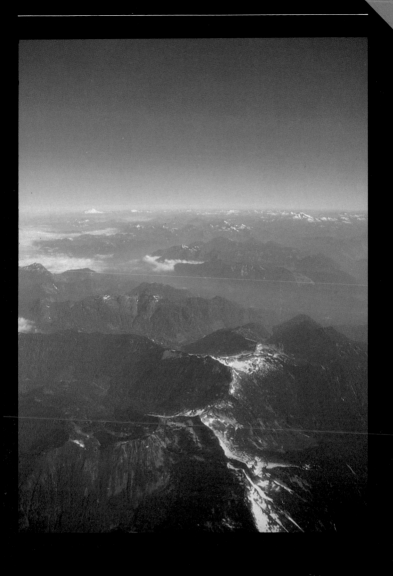

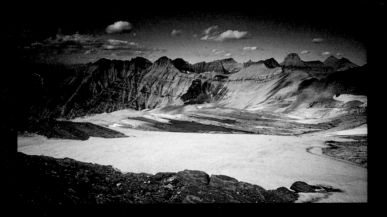

POLAR LIGHT

PROBLEM SUMMARY: Long summer twilight and reflective snow cover makes exposure difficult to judge.

Just as tropical light from a high sun is unfamiliar to most photographers, low polar sun creates conditions that can seem odd at the time. Polar summer days alternate between a sun quite low on the horizon and twilight; this gives ample time and interesting light for photography, but confuses the eye's judgment of light levels. As with tropical light, believe your meter rather than your judgment, but make allowances for snow and ice. Polar winter is largely polar night; long exposure times are essential in order to capture any detail at all on film.

SNOW, ICE AND WHITE-OUTS Where polar regions have a permanent covering of snow or ice, the main problem is calculating the best exposure. Faced with an overall white scene, any exposure meter will show a setting that gives a dark image. Keep exposures one or two stops brighter than the meter reading from the

RIGHT Although polar landscapes are spectacularly different from most, their elements and colors are limited, making variety of lighting even more important than it is normally. This elegant and stark view of tidal ice in northwest Greenland draws much of its power from being taken under moonlight. The high reflectivity of snow and ice compensate for the dim illumination, and the exposure, on ASA 64 film, was relatively short at less than one minute at f2.
(© Time-Life Books)

snow. (GO TO PAGES 92-3, SNOW.)

With little or no vegetation and few other features not covered with snow, contrast is usually low. Backlit views, from a camera position facing into the sun, or nearly so, improve contrast.

In bad weather, sky and land may become so similar in tone that they appear to merge. To take any kind of photograph in this condition, known as a 'white-out', shoot very close to a recognizable subject. Under a clear sky, snow and ice will appear blue. (GO TO PAGES 92-3, SNOW.)

REVERSING THE PROBLEM: **For their unusual light and scenery, polar conditions can be visually exciting.**

A low sun and twilight are conditions that many landscape photographers consider ideal. In polar regions in fine weather, these are the only types of lighting. Where there is continous snow or ice, the landscape setting is so reflective that photographs by moonlight are especially easy.

CAMERA AND FILM FAULTS

Equipment malfunction is the most immediate of all photographic problems. Although many photographers would probably rate it the most serious, the majority of equipment problems can be solved by rereading the instruction manual. This, at least, is the experience of the people who make and repair the equipment - that operator error is the main culprit.

Nevertheless, if you use cameras for long enough, and particularly if you put them to work seriously, a real malfunction will sooner or later occur. Experience helps in avoiding the obvious errors, but cameras, lenses and film are sufficiently complex to provide some surprises for everyone. If something goes wrong when you are at home and are not planning to take photographs for a week or two, the manufacturer or a repair shop can take care of it. However, a malfunction is just as likely to occur, maybe more so, when you are away from home using the camera.

This section of the book examines all the common and important mishaps that can affect equipment, and also the faults that they cause on film. It is a three-way approach: diagnosing faults, anticipating the effects of different kinds of damage, and looking for the common ailments in different parts of the camera and lens.

Remedies can be either preventative or curative. Many cures simply must be left to professional repairers - major camera surgery needs an expert, not an amateur - but first aid is usually worth attempting. Even blemished transparencies and negatives can often be restored or improved later in the darkroom or on the retouching table.

Never leave a fault unidentified or untreated. You may never know when it will recur, and that could be when you are least able to cope with it.

FAULT-FINDER

More often than not, faults show up first in the worst place of all - on film that has already been developed. The next pages provide a checklist of symptoms; compare the fault in your roll of film with the damaged strips to find the closest example. Check whether this is the type of fault that would be likely to result from the way the mechanism works, and whether it is consistent with any damage the camera or film has suffered recently.

Retouching techniques are covered on pages 184-6, and the prognosis for restoring a picture is given for each fault.

3: Old film

SYMPTOMS Pale image, weak shadows, with a greenish color cast.

CAUSE Ageing, caused either by film being used long after the expiry date marked on its box, or by being stored at high temperatures before use and processing. The effect is worse if the film is carrying a latent image.

TREATMENT Store film as recommended; use before expiry date; process promptly.

CHANCES OF RESTORING FILM Poor. Duplicate to increase contrast.

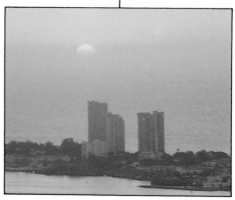

1: Tungsten film in daylight

SYMPTOMS Strong overall blue cast.

CAUSE Type A or B (tungsten-balanced) film used in daylight, or tungsten-balancing filter (81B or similar) left on lens.

TREATMENT Check film, filters.

CHANCES OF RESTORING FILM If transparency, poor. If negative, adjust enlarger's filter pack. Can make satisfactory black-and-white print.

2: Overexposure

SYMPTOMS Pale image.

CAUSE Film speed too low; meter inaccurate; aperture and diaphragm failing to close down; shutter sticking open; over-development.

TREATMENT Check settings, meter, aperture, shutter, development.

CHANCES OF RESTORING FILM If transparency, none. If negative, use print controls.

4: Underexposure; light subject

SYMPTOMS Image appears too dark; on negative film, it looks pale.

CAUSE If the subject is bright (such as snow, sand and foaming waves) and the image is grey, the fault is the result of failing to compensate for the natural brightness of the subject.

TREATMENT Light subjects need to appear brighter than average. Open up one or two stops from the direct meter reading; or take an incident reading with a handheld meter; or take a reading from a nearby, average subject and use that instead.

CHANCES OF RESTORING FILM If transparency, moderate to poor. Copy on duplicating machine but expect no detail in shadows. If negative, good to moderate. Use high-contrast paper (if black-and-white) and print controls.

5: Underexposure; average subject

SYMPTOMS Image too dark; on negative, appears pale.

CAUSE Camera fault is likely. Film speed set too high; meter inaccurate; exposure mistake on handheld meter transferred to non-metering camera; second shutter blind following first too quickly; film underdeveloped.

TREATMENT Check film speed setting, meter calibration, shutter, development.

CHANCES OF RESTORING FILM If transparency, moderate to poor. Copy on duplicating machine to lighten overall and improve contrast. If negative, good to moderate. Use high-contrast paper (if black-and-white) and print controls.

FAULT-FINDER/2

6: Gross underexposure
SYMPTOMS Virtually no discernible image: transparencies almost black, negatives almost transparent. Important to distinguish between this and no image at all.
CAUSE With gross underexposure, wrong control settings or operator errors are not likely. Shutter is probably faulty; or too fast a shutter speed on a leaf shutter was used with flash.
TREATMENT Check shutter; it will probably need professional repairs.
CHANCES OF RESTORING FILM None.

7: Unexposed film
SYMPTOMS Transparencies black, negatives transparent. No trace of image.
CAUSE Film not exposed. Either it has not been through the camera (film tongue not attached securely to take-up spool) or light from the subject never reached the film. In the latter case, shutter may not have opened, the mirror may have failed to move, or a very high shutter speed was used on an SLR camera with flash.
TREATMENT Check the shutter. If you were using flash, make the same shutter checks while firing the flash.
CHANCES OF RESTORING FILM None.

8: Diaphragm flare
SYMPTOMS Polygonal light blemishes, often in a row, pointing toward bright light source.
CAUSE Flare from aperture diaphragm. The shape is that of the opening.
TREATMENT Effective lens shading.

CHANCES OF RESTORING FILM Poor; only with careful retouching.

9: Lens flare
SYMPTOMS Pale fogging in backlit shots.
CAUSE Ordinary lens flare caused by light scattering from front lens surface. Distinguished from light leak by being diffuse and by not affecting the film rebates. Likely to be exaggerated by any filters.
TREATMENT Shade lens effectively and remove any filters.
CHANCES OF RESTORING FILM If mild, print controls and shading during duplicating will help to make it less obvious.

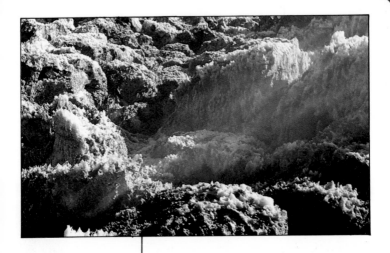

10: Flare from dirt and grease
SYMPTOMS Pale streaks on backlit shots, pointing toward light source.
CAUSE Dirt or grease on lens.
TREATMENT Clean; shade effectively.
CHANCES OF RESTORING FILM Moderate. Retouch.

11: Flare from spray
SYMPTOMS Mottled pale patches on image. The shape of these will be indistinct or roughly circular. Most prominent in backlit shots.
CAUSE Flare caused by droplets of water or other liquids. Typically occurs on rainy days or by the seaside if it is windy.
TREATMENT Keep checking the front of the lens if shooting in these conditions; wipe when necessary.
CHANCES OF RESTORING FILM Good to poor, depending on extent. If only small areas are affected, retouching will help.

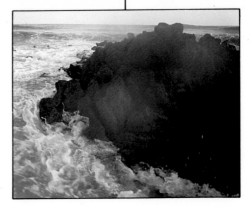

FAULT-FINDER/3

12: Graduated filter in wrong position

SYMPTOMS Light falls off in one direction.

CAUSE Obstruction. This can happen if you are using a graduated filter to darken the sky and then forget to rotate or remove it when you change format.

TREATMENT Check filters regularly.

CHANCES OF RESTORING FILM Quite good. Shade when printing or when duplicating (possibly by using the same graduated filter).

13: Pink sky

SYMPTOMS Discolored sky.

CAUSE Some makes of color film react oddly even to neutral graduated filters. This example is typical of Kodachrome 64 used with a Cokin grey graduated filter. Another cause of this fault is the inadvertent use of a colored graduated filter.

TREATMENT Use a different make of film, no filter or a filter of a mild opposite color.

CHANCES OF RESTORING FILM Good. If negative, print with filter of opposite color shaded over discolored area. If transparency, use similar technique, (opposite color if duplicating; same if printing).

16: Polarizer used through aircraft window

SYMPTOMS Rainbow colors

CAUSE Certain types of aircraft window.

TREATMENT Remove lens; in small aircraft, open window.

CHANCES OF RESTORING FILM None.

17: Polarizer; wide-angle lens

SYMPTOMS Blue sky varies in tone across picture.

CAUSE Polarizers only darken the part of the sky at right-angles to the sun.

TREATMENT Remove filter.

CHANCES OF RESTORING FILM Shade when printing or duplicating.

14: Wrong lens shade

SYMPTOMS All four corners cut off; soft edges.

CAUSE Using a lens shade designed for a longer focal length of lens, or filter(s) that are too thick.

TREATMENT Remove shade or filters.

CHANCES OF RESTORING FILM Crop in printing (negative) or enlarge and crop when duplicating (transparency).

15: Mirror lock

SYMPTOMS Black, soft-edged cut-off at bottom of frame.

CAUSE Obstruction. This can happen if you lock up the mirror to reduce vibration on a slow-exposure tripod shot, but fail to move it all the way. Otherwise, the mirror is not traveling its full distance.

TREATMENT With the lens removed, check the mirror clears the shutter opening. If not, move gently by hand. May need professional repair.

CHANCES OF RESTORING FILM If cut-off does not obscure an important area, crop in printing (negative) or enlarge and crop when duplicating (transparency).

18: Unsynchronized shutter
SYMPTOMS Some or most of the image is completely black, separated by distinct line.
CAUSE Flash used with too high a shutter speed.
TREATMENT Check shutter speed correct for flash - probably 1/90 second or less. See instruction leaflet.
CHANCES OF RESTORING FILM None, but exposed area might make a satisfactory picture.

19: Shutter rebound
SYMPTOMS A dark, soft-edged band, usually on the right side. May occur intermittently.
CAUSE Shutter rebound in SLR cameras. Should not be confused with the fault that occurs when flash is used at too high a shutter speed. If band has a sharp edge, the shutter is probably sticking.
TREATMENT Professional repair.
CHANCES OF RESTORING FILM None.

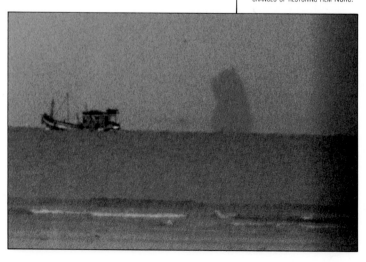

20: Focus beyond infinity

SYMPTOMS In a long-distance view, entire image is soft, less so toward infinity.

CAUSE Fluorite and rare earth glass lenses expand and contract with temperature changes and so are designed to focus beyond infinity.

TREATMENT Check visually when focusing; do not just move the focusing ring to the stop.

CHANCES OF RESTORING FILM None.

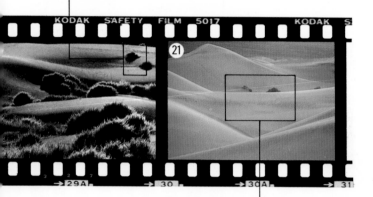

21: Out of focus

SYMPTOMS The image is soft, but not at all distances if the view has perspective.

CAUSE The most probable cause is not focusing exactly on the subject. Another likely cause is slippage of the focusing ring this is especially likely if you are using a tripod and the lens focusing ring is worn. Otherwise, the focusing screen is not seated properly, so that the film focuses differently from the viewing system. The lens itself may be damaged, but in an SLR camera you would notice this at the time of shooting.

TREATMENT Check focusing screen and lens, and check the focus at the film plane. Take more care over focusing.

CHANCES OF RESTORING FILM None, short of extensive retouching.

22: Twisted focus

SYMPTOMS The image becomes softer across the picture; the effect is not related to distance.

CAUSE The mirror box may be twisted slightly out of shape, following impact. Be careful to distinguish between this and other focus faults.

TREATMENT Take the camera for professional repair.

CHANCES OF RESTORING FILM None, short of extensive and skillful retouching.

23: Camera shake

SYMPTOMS All of the picture is blurred, with slight overlapping of edges at magnification.

CAUSE Moving the camera during exposure, most likely at slow shutter speeds. The overlapping edges distinguish this fault from soft focus, which looks smooth, and it is different from subject movement in that the entire image is affected to the same degree.

TREATMENT Use higher shutter speed for handheld work, or use a tripod with cable-release, locking mirror to reduce vibration. Shield camera from wind.

CHANCES OF RESTORING FILM Poor, but retouching may help.

24: Subject movement

SYMPTOMS Blurring of part of subject; overlapping images.
CAUSE Subject moved during exposure; likely if shutter speed was slow. If other parts are blurred, fault caused by camera shake. If no edges overlap, fault due to soft focus.
TREATMENT Slow down the movement and/or use a faster shutter speed.
CHANCES OF RESTORING FILM Poor, try retouching.

25: Multiple exposure

SYMPTOMS Two or more images on one frame of film. Usually appears overexposed.
CAUSE Multiple exposure due to rewind button being pressed inadvertently before winding on, or (on some cameras) double-exposure lever being operated by mistake. With some motor-driven cameras, this can happen at the beginning and end of the roll, when the drive fires the shutter without winding on the film.

TREATMENT Check control settings and anticipate the last frame of a roll.
CHANCES OF RESTORING FILM None.

26: Double exposure, overlapping frames

SYMPTOMS Part of a second image on one frame. Checking the complete roll shows overlapping frames.
CAUSE Most likely cause is reusing an exposed roll of film by mistake. In this case, the divisions between the originally exposed frames should be distinct, but if there is no

thickness to them, the wind-on mechanism may be faulty.
TREATMENT You may be able to identify from the pictures whether they were shot at different times or places. If so, invent a system for separating unused and used rolls of film. Check the wind-on mechanism when loading a new roll of film to see that the film travels a full frame's length each time.
CHANCES OF RESTORING FILM None.

FAULT-FINDER/6

27: Tension marks
SYMPTOMS Regular series of vague patches along the edge of the film, related to the sprocket holes.
CAUSE Probably due to the film being pulled too strongly. This can happen if the film advance lever is worked violently, or with some motor-drives.
TREATMENT Wind film on gently. Consider not using the motor-drive.
CHANCES OF RESTORING FILM Moderate, if retouching is carried out. If possible, crop the picture to remove damaged portions.

28: Scratches
SYMPTOMS Light or pale blue streaks, usually parallel to the film edge.
CAUSE Often due to particles of grit scraping the emulsion surface. Straight, recurring scratches are often the result of grit in the camera back or film cassette; deeper, irregular ones occur when wiping film after processing.
TREATMENT Keep inside of camera back clean; handle wet film gently.
CHANCES OF RESTORING FILM Poor, but retouching the non-emulsion side may help. With negatives, knifing or bleaching the print is best.

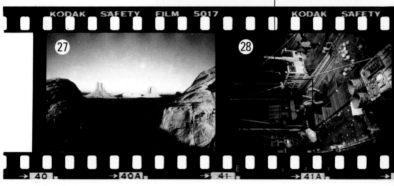

31: Processing stain
SYMPTOMS Discoloration in patches.
CAUSE Processing fault.
TREATMENT If you processed the film yourself, check the procedures carefully. If the film was processed by a lab or film manufacturer, complain.
CHANCES OF RESTORING FILM Moderate to very poor; retouch on enlarged duplicate.

32: Light leak
SYMPTOMS Some or all of the image will be washed out, in streaks or patches, usually yellow or orange in color.
CAUSE Light leak in the film cassette, camera, darkroom or in the processing tank. This will show up if the patches or streaks extend into the film rebates. The most common cause is opening the camera

29: Buckled film

SYMPTOMS Obvious crease in film; some discoloration.
CAUSE Film was probably creased after processing.
TREATMENT Store films carefully with rigid backing, or store in mounts.
CHANCES OF RESTORING FILM Moderate, if retouching is carried out.

30: Crimp mark

SYMPTOMS Light-colored, often pinkish or bluish crescent on transparencies; dark crescent on negatives.
CAUSE Mark often caused by buckling film before processing.

This is most likely at either end of the roll.
TREATMENT Take care when separating film from spool and loading in developing tank. If film was processed by a lab, complain.
CHANCES OF RESTORING FILM Moderate, if retouching is carried out.

back in light before rewinding the film. Exposing film cassettes to bright sunlight is also dangerous.
TREATMENT Always make sure that unprocessed film is kept in light-tight compartments or containers.
CHANCES OF RESTORING FILM Film can only be restored if it shows mild streaks; in this case, retouch.

33: End or start of film

SYMPTOMS Apparent light leak on part of the frame (not on rebates), separated from image by a ragged line.
CAUSE Occurs at either end of the film roll if the shutter is fired before first or last frame.
TREATMENT Watch the film counter carefully.
CHANCES OF RESTORING FILM Only by severe cropping.

CLOSE-UP CALCULATIONS

PROBLEM SUMMARY: *Magnification affects exposure. Unless the camera is fully automatic (including flash), variable adjustments need to be made.*

Light falls off with distance, so that the longer the lens, the more light is needed for the same result. For close-up photography the lens is extended forward (with the focusing ring of a macro lens, extension tubes, or extension bellows); this increases the magnification and reduces the amount of light reaching the film. To compensate, the aperture must be widened, the shutter left open for longer, or the light source increased or brought closer.

With continuous lighting, such as daylight or a tungsten lamp, the camera's through-the-lens meter automatically compensates; it measures the light after it has passed through the lens. With flash lighting, this also happens if the camera's meter can read directly off the film (separate sensors on automatic flash units are unreliable at close distances).

If your camera does not have these facilities, use the close-up guide and apply the results to the normal exposure reading.

FAR RIGHT The special allowances for exposure and light that are a constant feature of close-up photography begin when the image on the film is at least one-seventh the size of the subject. Most flowers, therefore, fall into the realm of close-up. These bluebells were photographed at a magnification of one-third and are here reproduced life-size.

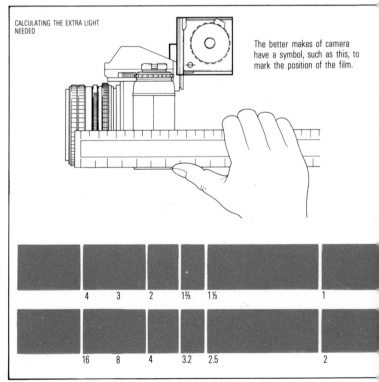

CALCULATING THE EXTRA LIGHT NEEDED

The better makes of camera have a symbol, such as this, to mark the position of the film.

4	3	2	1⅔	1⅓	1
16	8	4	3.2	2.5	2

METHOD 1

Start by working out the distance from the lens to the film. The film's position is always close to the back of the camera, and the center of the lens can be found by measuring its focal length forward from the film when it is focused at infinity. In this example the length is 55mm. Note the point on the lens barrel, and use it for all future calculations. Measure the total distance from the lens to the film, whether you use an extension ring or bellows, then divide the distance by the focal

length of the lens and square the result. For example, with the bellows above, the 55mm lens is 165mm from the film.

$(165/55)^2$ is 3^2, which is 9. To give nine times more light than a normal meter reading, open up 3½ f-stops.

EXPOSURE INCREASE

⅔

F-STOP INCREASE

1.6

METHOD 2

A quick method, needing no arithmetic, is to focus first on the subject and then to aim the camera at the table (LEFT). Adjust the view so that the lefthand edge is right up against the left side of the frame and the table is in focus. Read off the exposure increase calculation through the viewfinder.

TEST PAGES

Use these three tests to check meter consistency, lens resolution, and color film accuracy. The two large rectangles - white and black - cover a range of four f-stops and are designed to provide a test for meter consistency. Read each one in turn with your meter under any normal lighting; the differences in the readings should be the same as those printed. Compare separate meters.

The target of small parallel lines, when photographed at the right combination of distance and lens focal length, is one basic test of lens sharpness and gives a reading in the number of lines per millimeter resolved.

The colored target is useful for comparison with developed color film. Use it for any shot where color fidelity is essential, such as copying a painting; place this page next to the subject and include it in at least one frame. Make sure that the color balance of the lighting is neutral - with daylight film, use flash or direct sunlight.

40 TIMES LENS FOCAL LENGTH

TESTING THE RESOLVING POWER OF A LENS
1. Use fine-grained film, and place this open page flat-on to the camera, in order to photograph the two boxes (RIGHT). It is important that the distance between the camera and the page is exactly 40 times the focal length of the lens (ABOVE), ie 2m with a 50mm lens, 1.12m with a 28mm lens, and 4m with a 100mm lens.
2. Use a powerful magnifying glass on the processed transparency or negative to observe the lines: the thinnest that still appear separated mark the resolving power, in lines per mm. The scale runs between 10 and 72 (TOP RIGHT).
3. As a general rule, a good lens resolves at least 32 lines per mm in the center of the picture at maximum and minimum apertures, and 24 lines per mm at the corners. At the middle aperture, resolution should be at least 36 lines per mm in the center, and 32 lines per mm in the corners.
LEFT To evaluate the color fidelity of different films, these colored boxes can be photographed and the results compared with the original.

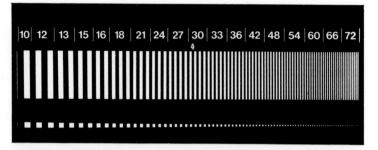

EXPOSURE PROBLEMS

Automatic through-the-lens metering takes care of exposure in most situations - it is designed to measure the exact picture that is about to be taken. Nevertheless, there are occasions when pictures turn out too dark or too light.

Unless there is a camera fault, exposure problems have one root cause: a meter shows how to reproduce whatever it is pointed toward in an average tone (that is mid-grey if you are using black-and-white film, or its colored equivalent on color film). This happens to suit the majority of subjects - landscapes, buildings, and so on - but not all. As non-standard situations are often the most interesting, careful metering is more important than it might at first seem. For example, a white wall or a field covered in snow, are both obviously bright subjects and need to appear so in a photograph to look realistic. However, if a meter is pointed toward either of these, the reading will show how to turn it into a grey image.

Personal preference is also a consideration. Some people prefer images that are darker or lighter than normal or decide to alter the brightness in the photograph to make it more dramatic, more graphic, or to emphasize a particular area. For consistently darker or lighter pictures, either set the film speed dial on the camera (or on a separate meter) higher or lower than recommended, or, with non-automatic metering, remember to keep the reading slightly up or down. A third or a half of an f-stop is the normal margin.

Aside from questions of taste, all exposure problems fit into one of the following situations:

ABOVE Most cameras have a control that allows the photographer to choose consistent over- or underexposure. Once set, use the camera's through-the-lens meter normally. A simple alternative to this control is to pretend that the film is either faster or slower: to obtain slightly darker pictures with ASA 64 film, for example, set the film speed dial to ASA 100, and to obtain lighter pictures, set the dial to ASA 50.

● **LIGHT SUBJECT** If the subject (not the lighting, which can be bright or dim) is lighter than average and needs to stay light in the photograph, there are two solutions. One is to increase the meter reading. Use your judgment for the exact increase; if you want a bright white add two stops (for example, f16 becomes f8), but if you want just a light tone add one stop

The other solution is to take a reading of a more average subject nearby under the same light, and use that. Incident readings through a milky plastic dome on a hand -held meter give the same result, as do readings from a special '18% grey card' sold by Kodak and other manufacturers.

Typical light subjects are snow, pale

sand, foaming waves, whitewashed buildings and clouds.

● **DARK SUBJECT** Subjects such as black skin, dark rocks, and anything painted black create the same type of problem as light subjects; the solution is also the same. First decide how dark you want the photograph to be, then either reduce the reading from the meter (by, say, two stops if you want it to be very dark, or one stop for quite dark), or take a reading from something average.

● **SMALL, DARK SUBJECT ON LIGHT BACKGROUND** Either backlighting or the subject itself can create this tonal contrast. In either case, a regular meter will read the background, and this setting will result in a silhouetted image. Some judgment is needed; decide whether you want a silhouette or whether you need to show detail in the subject at the expense of a featureless background. If the former, follow the reading, or possibly increase the exposure by one stop. If the latter, increase the exposure by two or three stops, or take a reading from the subject alone with a spot meter, or by moving closer. In any case, bracket exposures.

● **SMALL, BRIGHT SUBJECT ON DARK BACKGROUND** Set the exposure for the subject, not the background. Try to take a reading for the subject alone and then decrease the setting by about one stop; otherwise, take a reading from an average subject nearby in the same lighting. Bracket exposures.

● **HIGH CONTRAST** What you do depends on the contrast range of the scene. If the difference between shadows and highlights is within the range of the film (roughly, five stops for transparencies, seven stops for negatives), take a reading from each and split the difference. For example, if the shadow reading is f4 and the highlight reading f16, expose at f8. (If the contrast is greater, GO TO PAGES 94-5, HIGH-CONTRAST LIGHT.)

● **APERTURE-PRIORITY METERS** A special problem of automatic cameras that have aperture priority (that is, you set the aperture and the shutter speed adjusts automatically) is that, without realizing it at the time, you may be taking a shot that is perfectly exposed, but blurred. The shutter speed needed depends on the speed of the action (GO TO PAGES 10-11, FREEZING MOVEMENT). When shooting moving subjects, keep an eye on the viewfinder display and set the aperture wide. In poor light, it may be safer to use manual metering to avoid camera shake.

Using the control to alter the calibration of the meter can prove dangerous if you only want occasional darker or lighter images, rather than a whole set. Many photographers also prefer to leave the film speed dial set normally, and instead of centring the meter display (TOP), they give each shot a bias, towards plus for lighter pictures (CENTER) and towards minus for darker (BOTTOM).

EXPOSURE PROBLEMS/2

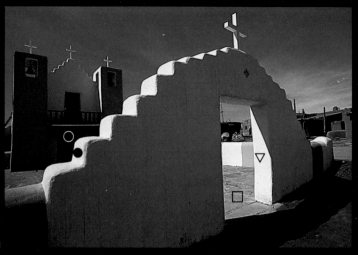

1

RECOGNIZING THE KEY DETAIL

Each of these photographs poses a different exposure problem, but all can be solved by recognizing the 'key' detail and making the exposure suit that.

1. Here the problem is high contrast; the exposure was set halfway between highlight and shadow.

2. An average reading would result in underexposure because there are only a few limited tones of white; the picture would be ruined if the brightest white appeared washed out. The solution is to take a reading from the white sand and then open up the aperture by two stops.

3. Here a light background dominates - the solution is to ignore the sky and set the exposure for the bird, taking a reading from an average area out of the picture.

4. The girl appears so small in the shot that a regular meter reading would cause gross overexposure. The background is unimportant - the solution is to take a reading from a larger sunlit area out of the picture.

5. The dark skin is the key detail, but is not average in tone. The answer is to take a reading of the skin but close down the aperture by one or two stops.

KEY

● KEY DETAIL
○ DARKEST SHADOW
▽ BRIGHTEST HIGHLIGHT
□ AVERAGE TONE

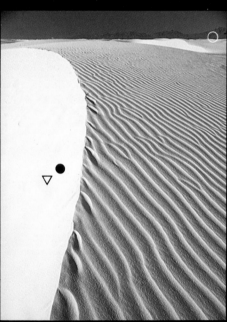

2

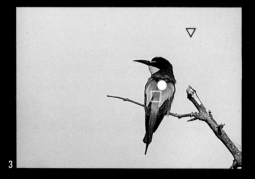

3

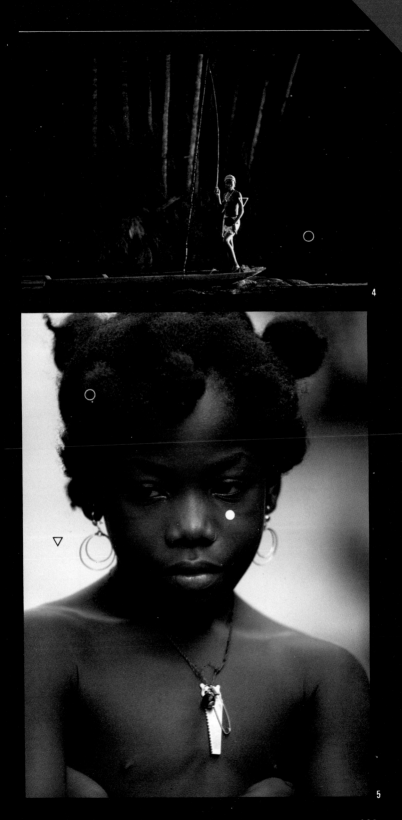

4

5

FLARE

PROBLEM SUMMARY: Bright lights in a scene, or just outside it, can weaken an image and spoil it with streaks.

There are different types of flare, depending on the cause and the lens. Light striking the aperture diaphragm creates a line of iris-shaped lights, especially in a wide-angled lens; even a little grease on the lens will create streaks; light on the front of a telephoto lens will fog the view.

AVOIDING FLARE

● **USE A LENS SHADE** Shade the front of the lens so that no light from outside the picture can enter. If the camera is on a tripod, stand in front and hold a card so that its shadow just falls across the lens.

● **CLEAN THE LENS** Any dirt or grease is likely to increase flare. When shooting into the sun, make sure that the lens surfaces are spotlessly clean.

● **REMOVE FILTERS** If the first two remedies do not work perfectly, remove any filters. The extra glass surfaces may be adding to the flare.

● **BUY A WELL-COATED LENS** Expensive remedy though it may be, if you have an uncoated or poorly coated telephoto lens, replacing it may be the only way of avoiding persistent flare in backlit pictures.

● **USE AN ASPHERICAL LENS** When bright lights appear in the scene being photographed, which is typical of many night-time views, a lens that has an aspherically ground front surface is better at controlling flare than the more conventional lenses that have spherical surfaces. It is, however, costly.

REVERSING THE PROBLEM: By degrading the detail and color, flare can simplify images and add atmosphere, while specific flare patterns may be attractive.

BELOW Different styles of lens shade reflect varying degrees of compromise between convenience and efficiency.
1. Built-in sliding hoods are common in long-focus lenses.
2, 3. Detachable hoods to suit different focal lengths are easy to manufacture but not necessarily exact.
4. Rectangular hoods are exact but only work on bayonet fittings.
5. Collapsible rubber hoods simplify packing.
6. Adjustable bellows shades meet professional requirements and are the most efficient of all.

1 2 3

Flare may be an enemy of the crisp, detailed photograph, but it has several uses when mood is more important. Encouraging flare is relatively easy; simply point the camera toward bright lights, take off the lens hood and, if necessary, dirty the lens or add special filters. Most special effects filters work by inducing some kind of flare.

OVERALL FOG WITH A LONG-FOCUS LENS In a long-focus lens flare usually affects the entire picture area, and not just a small part of it. This actually makes it very easy to use, as the effect is simple, and uncomplicated by streaking. The broad flaring brightens the image and suffuses it with the color of the light source (a setting sun may add an orange cast), helping to unify an image.

HALOS AROUND LIGHTS A soft-focus filter, or grease thinly smeared on the lens, produces a soft fringe, sometimes colored, around the bright areas in a photograph. This works even more effectively with large areas of light than with small points and can be useful when photographing windows and open doorways from inside (GO TO PAGES 32-3, SPECIAL SETTINGS; 42-5, INTERIORS). It is safer to smear grease on a plain filter than on the lens itself. Very fine, thin material such as muslin also has a flaring effect.

PATTERNS OF FLARE WITH A WIDE-ANGLE LENS Flare in wide-angle lenses tends to be localized in the picture, often as an overlapping line of bright polygons (caused by the shape of the aperture). Used occasionally, this effect can add a strong diagonal component to the image, and also gives a good impression of glaring brightness. You can control the exact appearance of this type of flare by moving the camera slightly relative to the light source and by changing the aperture setting. The effect is strongest when the light is just at the edge of the picture. A thin coating of grease creates simple rays of light.

ABOVE The most accurate shade is one that just cuts off direct light from striking the lens. If the camera is fixed, one simple method is to hold your hand as shown, judging its position by looking at the shadow it casts on the front of the lens. Alternatively, in a studio, fix a piece of black card on a stand.

4 5 6

REDUCING OVERALL FLARE Telephoto lenses are prone to generalized flare that simply degrades the whole image. These two photographs, taken into the sun with a 400mm lens, are identical except that for the upper picture the standard lens hood was used, while for the lower the lens was shaded by hand.

USING FLARE The generalized flare which results from the use of a telephoto lens can lend certain views a distinct atmosphere. The evening scene of rice fields, taken with a 400mm lens, is suffused with the particular color of the sunlight at that time of day (ABOVE). Patterns caused by flare can also add to the composition of a picture and are not always elements photographers should strive to eliminate. The string of aperture reflections in the wide-angle photograph of a mountain lake (taken with a 20mm lens) adds a diagonal line to the image and suggests the intensity of the sun (TOP RIGHT). In the aerial view of the Orinoco River delta, flare from the aircraft window makes the sun an important element of the composition (RIGHT).

MAINTENANCE KITS

Some of the most important accessories are the tools that can keep cameras and lenses clean and functioning. Not all the items in a full maintenance kit are necessary if your equipment is professionally cleaned by the manufacturer or a repair shop; however, doing your own cleaning not only saves money but also gives you a familiarity with the mechanics that can be valuable when something malfunctions. A traveling kit, on the other hand, is essential.

HOME MAINTENANCE KIT

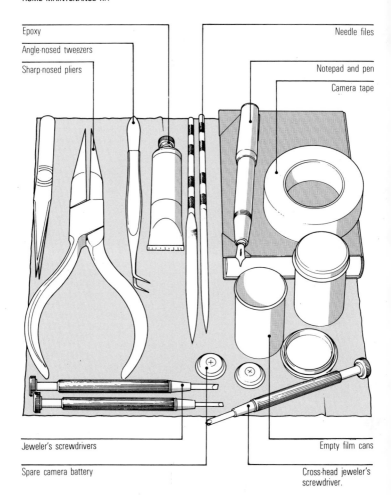

Epoxy

Angle-nosed tweezers

Sharp-nosed pliers

Needle files

Notepad and pen

Camera tape

Jeweler's screwdrivers

Spare camera battery

Empty film cans

Cross-head jeweler's screwdriver.

ABOVE This small set of tools is for emergencies, only to be used when a repair is essential, and if you know what you are doing. Use screwdrivers, pliers and tweezers for the basic dismantling and bending of parts into shape, and epoxy for sticking broken parts together. Before applying epoxy, use needle files for smoothing down broken parts and for cutting new grooves into stripped screw heads. Store small parts in empty film cans during repair work. Spare batteries are essential given the number of electronic functions, and easier to fit. Always use a notebook to keep a detailed record of any repair work that you have carried out, as a reference.

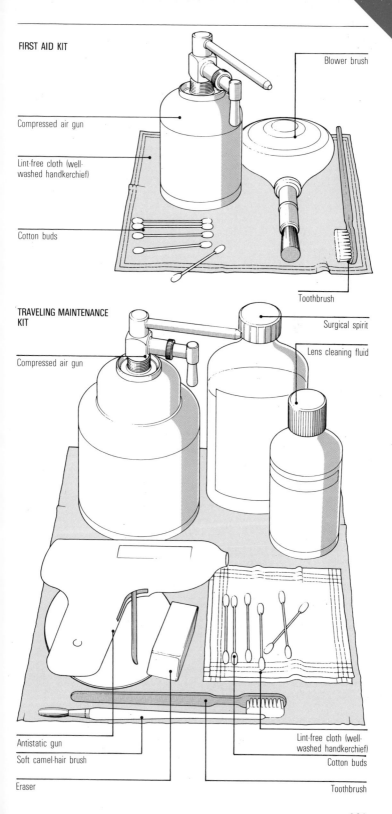

FIRST AID KIT

Compressed air gun

Lint-free cloth (well-washed handkerchief)

Cotton buds

Blower brush

Toothbrush

TRAVELING MAINTENANCE KIT

Compressed air gun

Surgical spirit

Lens cleaning fluid

Antistatic gun

Soft camel-hair brush

Eraser

Lint-free cloth (well-washed handkerchief)

Cotton buds

Toothbrush

CAMERA CLEANING

Cleaning saves repair. Dirt can clog mechanisms, scratch film and glass and even wear down and loosen some moving parts, such as the lens focusing ring. (GO TO PAGES 134-5, DUST AND SAND.) Apart from full-scale cleaning after a trip, when the camera is obviously dirty, also clean regularly and as often as possible.

Because grit can scratch, never begin by using a cloth on delicate surfaces or you may simply wipe particles into the glass or plastic. The safest method is first to blow away loose particles with compressed air or your breath, then to brush away the remainder. Finally, wipe with a clean cloth.

Use these cleaning diagrams to avoid missing essential parts. Always work on a clean surface and in clean air.

Use compressed air first on delicate parts, but keep can upright at all times

Use a toothbrush for stubborn dirt on the exterior of the body

Use a soft, lint-free cloth for wiping

Follow air cleaning of delicate surfaces with a blower brush. If used on delicate parts, remove brush to prevent hairs getting trapped inside

A small typewriter cleaning brush is useful for sturdy areas inside the camera body

Body crevices and awkward corners

Lens: Use air first, then breathe on surface and wipe carefully in spiral motion outwards from center. Use lens cleaning fluid only when very dirty
Prism and screen: Use air first, then wipe. Do not wet, as water will seep between glass and fresnel screen. Use cotton buds for awkward corners
Mirror: Use extreme care; scratches easily. Use air first, then soft brush

1. The exterior of a camera body is not delicate, and can be treated firmly. A cotton bud or toothbrush is ideal for working around the crevices on the top plate and on either side of the lens mounting.
2. Clean the focusing screen, mirror or pentaprism surfaces right into the corners.
3. Keep battery surfaces clean using a small eraser to ensure good electrical contact.

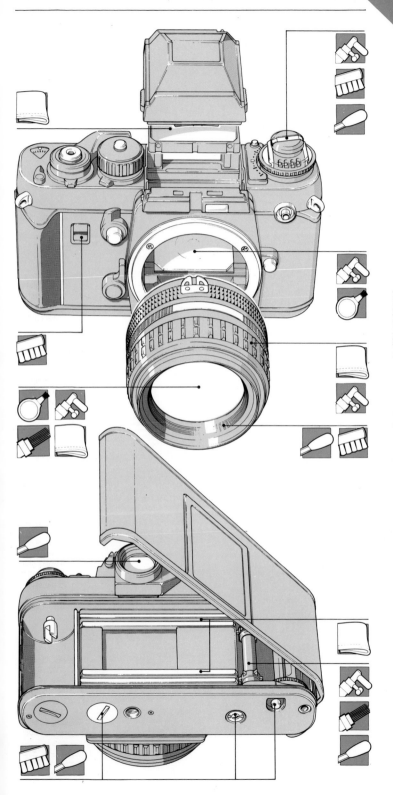

WATER

PROBLEM SUMMARY: Because it corrodes metal parts and shorts electrical circuits, a complete wetting is a thoroughly effective way of ruining a camera.

Use a soft cloth for wiping dry and for soaking up moisture

Use cotton buds to soak up moisture from small spaces

A hair-dryer is a fast method of drying a camera. Otherwise use direct sunlight or a radiator

Although a few drops of rain are of no importance, water inside a camera can be permanently damaging. If a camera or lens is dropped in water, the implications are serious; saving the equipment depends on taking fast action and being able to reach a repair shop quickly. If wet conditions are expected, the best precaution may be to use a waterproof camera, such as the Nikonos.

A LIGHT SHOWER A light surface wetting is not likely to have any effect at all, but it is a good idea to prevent droplets seeping inside by wiping the camera with a soft cloth.

IMMERSION IN FRESH WATER No ordinary camera body is watertight. If it falls into water, even for only a second or two, water will flood at least part of the mechanism. Once inside, water can corrode metal parts (eventually) and short-circuit electrical components (immediately). Generally, if the camera is mechanical, it will probably continue to work straight away, but if it is electronic, it will probably not work. However, shorting is not permanently damaging; once the circuit boards are dry, an electronic camera should function again.

TREATMENT: 1. Remove the film. To save it, open the camera back in the dark (a windowless closet or bathroom) and pull the film out from the cassette as far as possible without detaching it. If it is already wet, keep it in water and have it processed quickly. If it is only partly wet, hang it to dry in complete darkness. Rewind it afterwards. (GO TO PAGES 170-1, MAKESHIFT DARKROOMS.)

2. Dry the camera. Leave the back open and remove the lens. Dry everything in direct sunlight, or with a hair dryer, or on top of a radiator. An oven could also be used, but carries the risk of overheating; if the camera becomes too hot to touch, it is reaching the danger point. (GO TO PAGES 138-9, HEAT.)

3. Even though the camera may work after drying, take it to a qualified repair shop as soon as possible.

IMMERSION IN SEA WATER Salt water is much more damaging than fresh, because it is more corrosive, more conductive (so it is

Resistors

Central processing unit

Printed circuit board

ELECTRONIC LAYOUT Electronic components are at risk of shorting, especially at solder points. The layout varies from model to model, but this arrangement is typical of an advanced electronic camera. The flexible circuit is wrapped around the body.

Water enters easily through the prism head, hinged back, and controls on the top plate and base plate. Follow procedures for drying

Electronic components short easily. Salt deposits from sea water can keep them shorted. Most internal metal parts are liable to corrosion, particularly from salt water

Water softens film emulsion. Remove film. Clean any sticky deposits from the film gate and rails with damp cloth

Battery may short. Dry with cloth

more likely to cause shorting), and leaves greasy deposits of salt after drying.

TREATMENT: 1. Immerse the camera completely in *fresh* water. Make sure that is flooded completely, to help wash away the salts. Don't just rinse it under a tap; put it in a bucket and swill the water around.

2. If you are within an hour or two of a repair shop or the manufacturer, take the camera there still in fresh water. Otherwise, dry as for fresh-water immersion.

3. After drying, take for repair.

DUST AND SAND

PROBLEM SUMMARY: Dust penetrates mainly through the camera and lens controls. It can grind, damage and jam moving parts, as well as scratch lenses, mirrors and film.

Compressed air in a small can is the most useful cleaning tool. Try it before anything else

A blower brush (squeezing it pushes the air out through the hairs) is less powerful than compressed air, but is small, light and convenient

Use a stiff toothbrush only for the outside crevices of the body that will resist scratching

A small stiff brush of the kind supplied with typewriters and sewing machines is good for small corners of the body

A slightly moistened cotton bud can also be used on the camera body

Screwdrivers and pliers may be necessary to gain access to the interior if dust has penetrated
Camera tape may be useful for sealing gaps in the body
Avoid wiping at all costs – it will cause scratching

Dust collects slowly but its effects are insidious; removing each particle from working mechanisms is a major exercise, particularly from areas coated with lubricant. The places where it enters are exactly those that are most at risk - the moving controls. The longer dust remains inside, the further it works itself into the mechanism, among gears where tolerances are fine and where it can cause more serious damage.

In terms of time spent on repair, dust and sand cause the most serious camera damage that manufacturers have to deal with. Sandy beaches are the main culprit. At the seaside, sand grains are coated with salt, which helps them to stick to equipment and can also cause some corrosion. Another situation fraught with risk is driving on unmade roads in dry weather - if other traffic is throwing up clouds of dust, it is likely to get into the fine mechanisms of the camera.

Avoid dust and sand by keeping the camera packed. An airtight case is best; otherwise, wrap equipment in cloth or plastic inside your shoulder bag. If airborne dust is likely, keep a check on the camera by listening for scraping sounds as you move the lens focusing ring, aperture ring and film advance.

TREATMENT: 1. Stop using the camera. Resist the temptation to continue working parts to see if the problem will clear itself - it won't. Once particles are inside, they will go deeper and do more damage if you continue turning the controls.

2. Remove the film. To avoid moving camera controls, remove the film in the dark, without rewinding (rewinding should be done by hand once the film has been removed from the camera).

3. Take off all removable parts (such as lens, back, and prism), raise the film rewind crank and extend the lens focusing ring fully forward. Remove all particles you can with compressed air or a blower brush.

4. Try the controls once. If there are still grating noises, put the camera away until you can take it to be cleaned by a professional repairer.

The gaps under the moving controls are prime sites for dust to collect. Clean with compressed air, followed by a small stiff brush

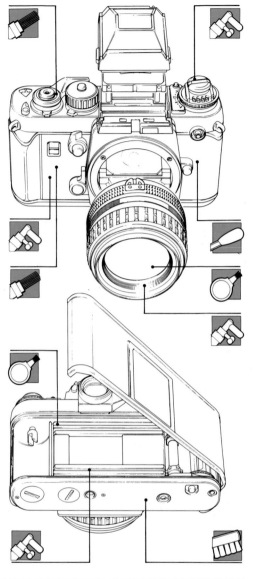

Gears and linkages may jam. If so, dismantle the body as far as possible. Clean with compressed air, followed by a small stiff brush (used with care)

The lens surface is liable to scratching by wind-blown sand. Protect with a plain glass filter. Clean with compressed air or blower brush. If scratched, have the lens reground

Dust can enter the focusing and aperture rings. Clean with compressed air and then a small stiff brush. If grains are embedded in lubricants, relubricating may be necessary

The film may scratch if grains lodge on runner rails. Clean with compressed air and a brush. Consider placing camera tape over the gaps between back and body

DUSTPROOFING EQUIPMENT The basic techniques for waterproofing a camera will also serve to keep out dust. Seal the camera in a plastic bag and secure with rubber bands. Use the open end of the bag for the lens, leave enough room inside to operate the controls and cut a small hole for the viewfinder, sealing it with another rubber band.

COLD

PROBLEM SUMMARY: Although cold is a problem only when it is severe, it causes condensation and this can be serious, particularly when there is snow.

A hair-dryer is a fast method of drying off condensation. Otherwise, use a radiator or direct sunlight through a window

Use a dry cloth for wiping and for drying

A blower brush will remove snowflakes from most parts

A small, stiff typewriter brush will remove snow from crevices

Camera tape can seal gaps temporarily and give partial insulation

If heavy condensation enters body, dry on radiator or with hair-dryer

EXTREME COLD At temperatures below about -13°F (-25°C) (wind-chill can create this even from higher temperatures), conditions are serious, and frostbite a real possibility. Do not expose your fingers. Wear silk inner gloves and use them when shooting; keep mittens on over them at all other times. Do not touch metal camera parts with your skin; it may stick and tear off. Wind film on gently; it is very brittle in extreme cold and may snap, and may also generate static sparks easily if moved quickly. Metals contract when cold, and this can sometimes affect the shutter mechanism, so alter the speeds. Titanium shutters are best, as they have a very low coefficient of expansion.

Take precautions against the cold when the temperature falls below freezing, or if the camera is likely to be moved suddenly from moderate cold into a hot room. Condensation is the main problem, and what causes it is a massive temperature change. There are other more specific conditions associated with cold, but these generally become important only at even lower temperatures.

PREVENTING CONDENSATION Ideally, if you are taking photographs in cold weather, keep the camera cold. If you bring it immediately into the warmth, moisture will condense on it all over - inside as well as out, and on interior lens surfaces - and the efect is that of a wetting (GO TO PAGES 132-3, WATER.) When you come to warm the camera up, take these precautions:

● Warm the camera slowly, bringing it to room temperature in stages (say, from outside to a front porch, then to an unheated hallway, then to the living room).

● Seal tightly in a bag or case. Heavy condensation needs lots of air containing water vapor, so seal the camera in a plastic bag or any container from which you can expel most of the air. Moisture will then condense on the outside of the bag. Pack with a desiccant – such as silica gel.

● In a snowfall, prevent snowflakes from entering the camera by taping it over. Wipe snow off instantly.

● Avoid breathing on the camera.

TREATING CONDENSATION (GO TO PAGES 132-3, WATER.)

PREVENTING REFREEZING Soon after taking a camera out into the cold, while it is still warm, any snow falling on it will melt and then quickly refreeze. If this happens in a joint, such as the hinge on the camera back, it may distort the metal by expanding. Let the camera get cold before taking it anywhere near snow.

KEEPING BATTERIES ACTIVE Batteries lose power in the cold. Be prepared for rapid failure and carry spares. A separate battery pack with extension lead that can be kept warm under clothing is useful. Dead batteries can be revived by warming. A selenium-cell meter generates its own current from light and is unaffected.

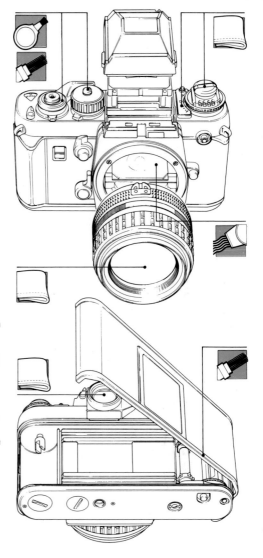

If camera has LCD display, crystals will react sluggishly

Wind film gently and without using force: it is brittle at low temperatures and may snap. All controls in top plate can trap snow that may refreeze. Brush, blow or wipe away. Clear ice later, in a warm room, by surrounding with a dry cloth or tissue to absorb moisture before it leaks into camera body

Condensation likely here. Cool camera before use, otherwise keep wiping with soft cloth

Snow or condensed breath can form ice on the hinge or anywhere along the camera back closure, and so warp the back, letting in light. Brush off snow immediately. Consider taping round the joints

Film becomes brittle; it may snap and show static marks if wound roughly. Rewind by hand when using a motor-drive

Slight contraction of metal parts makes shutter speed accuracy suspect, except in very best makes of camera

Battery performance drops. Tape covering the battery chamber lid slows down heat loss. Also keep a spare set of batteries inside warm clothing

On some motor-drives, a frame counter can be set so that the camera will stop after a certain number of exposures. In cold weather this is better than allowing the drive to continue to the end, which might tear brittle film.

CHECKING LUBRICANTS Some lubricants thicken when cold. If so, they may need replacing temporarily with thinner ones (a professional job, and expensive). Check whether this will apply to your camera by placing it for a couple of hours in a freezer set to the temperatures you expect to meet on the trip. Silicone lubricants, which are now now being used more and more by manufacturers in standard cameras, are largely unaffected by cold, and modern electronic cameras have fewer moving parts that can suffer from jamming.

HEAT

PROBLEM SUMMARY: *Although modern equipment is largely immune, high temperatures play havoc with color film, particularly when the air is humid.*

Use soft cloth for drying condensation

Use compressed air for reducing condensation instantly

THE SPECIAL PROBLEMS OF HUMIDITY
Wet tropical conditions need extra care, for the combination of heat and humidity is the worst of all for film, and is also bad for equipment. Keep everything packed in airtight cases except when you are shooting, with silica gel and little air-space. Inspect equipment regularly; look for signs of corrosion, and also for small patches on lens surfaces that are a sign of fungus, which destroys lens coatings and etches the glass itself. If these occur, take the camera for professional repair. It may not be possible to cure completely, and even though the fungus has apparently been removed, it may recur.

Heat has the effect of ageing film quickly, so that photographs appear paler overall; color film can develop a color cast, often greenish. Any temperatures over about 122°F (50°C) are likely to damage film quickly, and the ageing is accelerated by humid air. Check the expiry date on the film carton; for most films this is calculated for room temperature - about 75°F (21°C). As a rough guide, every 10° or 11°F (5° or 6°C) hotter than this halves the life of the film.

Modern equipment is tough and resists heat well. Lens cements, which used to be liable to soften and craze, are now more sophisticated; modern silicone and graphite lubricants keep their consistency. Over about 140°F (60°C), some of the electronics may malfunction but, in general, you are more likely to collapse from heat before the camera gives way.

KEEP COOL Refrigeration is not always possible when traveling, and is not necessarily desirable. Although ideal for storage at home, it can cause condensation if you move equipment and film in and out of freezers frequently. To keep film and equipment cool when moving from place to place in hot conditions:
- Keep in shade.
- Use cases that are white or silvered, or cover with a white towel.
- Ventilate (cameras or cases).
- Raise cases off the ground (ground temperatures are often much higher than those of the air above).

AVOID CONDENSATION Leave film in its prepacked containers until use – the rolls are factory-sealed in a dry air. As long as the film remains sealed, store it in a refrigerator if you can; after use, however, refrigerate. When you take unused film from a freezer, allow about one hour before breaking the seal. If you move equipment from cool to hot (such as from air-conditioning to a tropical midday), condensation is likely on lenses, mirror and eyepiece. To avoid this, warm the equipment gently, and plan ahead so that you do not have to rush out suddenly into the cold to take pictures at a moment's notice. (GO TO PAGES 136-7, COLD.)

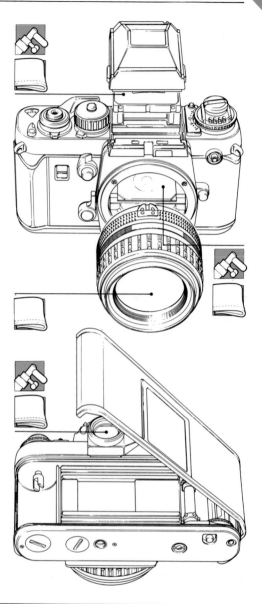

If camera has LCD display, crystals will deteriorate more quickly than normal

Condensation is likely in humid conditions and after sharp temperature change. Wipe with soft cloth, cool and dry by moving indoors or with compressed air

Fungus attacks glass in humid conditions, and looks like mottled patches. If just beginning, it can be wiped away with damp cloth, but if eroded, it is too late

The greatest risk is to film. If you suspect that it has been overheated, remove it immediately and refrigerate as soon as possible, before processing

SILICA GEL Silica gel is a dessiccant that soaks up moisture from the air like a sponge. Pack it with film and equipment if the humidity is high (but not in dry heat as it will then make the film brittle). For the best drying effect, use airtight cases and pack them tightly so that there is little empty space. One ounce of silica gel will keep nearly 1 cubic ft (0.3 cubic m) of air dry. It can be dried in an oven for reuse.

IMPACT

PROBLEM SUMMARY: Unlike other kinds of damage, impact injury is instantaneous and therefore not easy to diagnose. It can range from a loosened screw to irreparable breakage.

Although most cameras can take average knocks and scrapes in their stride, a severe drop is serious. The extent of the damage is usually difficult to assess, because even if you quickly find a major breakage, you will still need to check everything else to be certain that no more harm has been done.

Any impact resulting from a drop from a height of 2ft (0.6m) onto concrete needs eventually to be checked professionally, but make an immediate examination yourself. While practically anything may be broken, the experience of manufacturers' repair departments shows that some types of impact damage are more serious than others; look especially for these.

The areas of the camera which tend to be prone to this type of damage are:
- Components under film speed control.
- Film transport system.
- Lens elements.
- Lens mount and mirror-box.
- Prism.

IDENTIFYING DAMAGE 1. Find the point of impact. The front of the lens (especially if a heavy telephoto) and corners of the body are likely sites.

2. Make a visual inspection. Without moving any of the camera parts or controls, look for cracks, dents and misalignments. Examine the body face-on to the front, top, back and sides in turn and look for any signs of twisting.

3. Remove the film and separate removable parts, such as the prism head and camera back. Continue the visual inspection but also shake each part gently and listen for anything that rattles.

4. Work all the controls to see if each appears and sounds as if it is working normally. A spare camera will help you to make comparisons. (GO TO PAGES 144-9, FAULTY SHUTTER to FAULTY METER) and follow the specific checks, function-by-function.

5. Run a roll of film through the camera. You cannot be completely certain of the camera's condition until you check the results carefully. Look especially for focus problems. (GO TO PAGES 104-15, FAULT-FINDER.)

ABOVE Special camera cases, available from certain manufacturers provide the ultimate protection for equipment. Constructed from carbon fiber, they are capable of withstanding high pressure, a high degree of shock after impact, will float and are also waterproof.

Prism may be broken

Gears and connecting rods in the film transport may be bent or jammed if the impact is at either of these two corners. Check wind-on

Underneath the film speed control and rewind lever there is, in many cameras, a fragile glass component for the electrical circuit. Check operation of meter and shutter (if electronic)

All the glass elements are vulnerable to shattering and displacement. Check lens

Impact on the lens can twist the mirror-box. This can damage the aperture link to the lens, mirror operation and focus

Damage to baseplate may distort battery compartment, breaking contact

Film transport may be damaged by impact here

PROFESSIONAL REPAIR Camera manufacturers have their own specialized camera repair departments, where highly skilled technicians carry out repairs to particular camera models. It is important to leave all major repairs to such qualified experts, rather than attempt them yourself.

FAULTY WIND-ON

The film transport lever performs two functions at the same time - it winds on the film one frame at a time by means of a sprocket wheel, and it tensions the shutter through linkages in the base of the camera. In addition to the film transport lever, some camera bodies have a second connection in the baseplate, so that a motor-drive or automatic winder can be attached.

If a problem develops with this system, it is likely to be obvious immediately - the wind-on will jam or there will be a change in the sound of the gears and amount of tension. As with most equipment faults, it is a real advantage to be familiar with the feel and sound of normal operation so damage can be spotted as soon as it appears.

CHECKING When using the camera, watch the rewind lever on the left as you wind on. It should move and as long as it does, it clearly shows that the film is traveling toward the take-up spool. Don't worry if it hardly moves for the first few frames of a new roll - there is usually some slack to take up. Apart from film not being loaded properly, the most common fault occurs when the rewind button in the baseplate sticks and fails to re-engage.

IF THE CAMERA WILL NOT WIND ON 1. You may have come to the end of the film. Check the number showing in the counter. You may, for instance, have forgotten that you are using a 20-exposure cassette instead of one with 36 exposures.

2. Check that the locking lever is not engaged.

3. Check that the shutter has fired. (GO TO PAGES 144-5, FAULTY SHUTTER.)

4. If you were using the manual wind-on, attach a motor-drive or auto-winder and try again. If you were using a motor-drive, remove it and try to operate the camera manually.

5. Rewind the film and open the camera back. If the wind-on works then, suspect the film cassette - try another roll. If the film will not rewind, open the camera back in the dark, remove the film and wind it back into its cassette by turning the film spool. If the film will not even rewind like this, the problem is very unlikely to be in the camera.

6. Check that the rewind button in the baseplate is re-engaging properly. Work it a few times.

7. Roll both the sprocket wheel and the take-up spool with your thumb.

8. Turn the rewind lever to make sure that it is not jammed.

9. If none of the previous steps identify or free the fault, take the camera to a professional repair shop.

IF THE WIND-ON WORKS BUT THE FILM DOES NOT MOVE 1. Check that the film is properly engaged on both the take-up spool and the sprocket wheel. It may not have been loaded properly or may have torn loose. For safety, open the camera back in complete darkness.

2. If the film is torn (look for ripped sprocket holes), then the fault lies on the left-hand side of the camera as you hold it normally, either in the rewind mechanism or in the film cassette. Try pulling the film out of its cassette by hand.

3. Check the film cassette for dents; if it has become warped, this is probably causing the problem.

4. Turn the rewind lever to make sure that it is not sticking.

5. Try a fresh roll of film.

6. If none of these suggestions work, take the camera to a professional repair shop.

SHUTTER AND WIND-ON
In modern camera design, considerable work has been put into reducing torque - the twisting force needed to cock the shutter and wind on the film. Ball-bearings and simplified gear trains both help. Film advance levers are usually ratcheted so that they can be operated in several short strokes as well as one complete stroke. Rotating the gears, using the lever or the motor-drive coupling, tensions the shutter drum, rotates the take-up spool to pull the film along, cocks the mirror spring tensioning lever and moves the frame counter one number on.

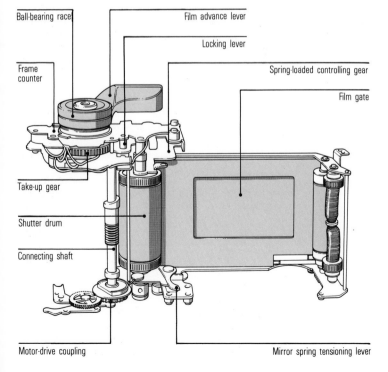

Ball-bearing race

Film advance lever

Locking lever

Frame counter

Spring-loaded controlling gear

Film gate

Take-up gear

Shutter drum

Connecting shaft

Motor-drive coupling

Mirror spring tensioning lever

FAULTY SHUTTER

ABOVE Most focal plane shutters consist of two blinds, each containing a gap. Exposure is controlled by timing the release of the second blind, which moves across to close the gap. At shutter speeds lower than about 1/60 second, the second blind follows the first so quickly that the gap becomes a narrow slit.

Of all the systems in a camera, the shutter mechanism is one of the most prone to faults. Because it is linked to most of the other systems - film transport, meter, mirror and lens diaphragm - shutter faults are often not isolated: if the shutter goes wrong, another system is also likely to be malfunctioning.

At slow speeds - 1/30 second or longer - the timing of the shutter can be heard distinctly, and if you use the camera regularly, this sound provides a constant check. Faster than about 1/125 second, however, shutter speeds tend to sound the same, particularly in SLRs, where the focal plane shutter actually travels at the same speed for all the higher speeds. As, in normal conditions, most photographs are shot at around 1/125 second, it is important to keep checking shutter accuracy regularly or you may find that you have wrong exposures on a number of different rolls of film.

Shutters are either leaf or focal plane, and the latter is far more common. Leaf shutters are set inside the lens, are normally very accurate and reliable, but are only practical with non-SLR cameras (SLRs like the Hasselblad that retain leaf shutters also need a second, focal plane shutter). Sticking, if it occurs, is usually due to lack of use, and is best prevented by firing the shutter over the whole speed range regularly.

Focal plane shutters work by traveling across the frame just in front of the film, either horizontally or vertically. The usual arrangement is a pair of blinds, each with a gap. At slow speeds (typically up to about 1/60 second) it is the delay between the first and second blinds that determines the exposure. At higher speeds, the two blinds travel together and the exposure is adjusted by narrowing the gap between them (this is why flash can only be used at slower speeds; otherwise, the exposure shows only a narrow gap).

CHECKING A jammed shutter is obvious, but an inaccurate one may seem to function normally and your first warning of a fault might be on the film. An electronic tester is needed for a precise check, and it is a good idea to have this done professionally every few months. However, visual checks can show you if the shutter is working more or less normally, and if you are right to within a margin of 25 percent, the exposures will be no more than half a stop out.

RANGE TEST
1. Remove the lens and, if possible, the camera back.
2. Hold the camera about 1ft (0·3m) in front of you and aim it at a bright area, such as the sky, a white wall or large lamp.
3. Looking at the shutter opening, operate all the speeds in rapid sequence, starting with the slowest. It should be obvious if the one-second speed is accurate; after that, concentrate on seeing if each speed appears twice as fast as the one before, as it should.
4. Do this test several times with the mirror operating normally, and with the mirror locked up, to see if there are any intermittent faults.

INSTANT FILM TEST
1. Polaroid instant film can be used to give a reliable test that may be checked on the spot.
2. Shoot a sequence of photographs, the first for 1/4 second at f22, the second for 1/8 second at f16, the third for 1/15 second at f11 and so on. These shots should give identical exposures.

COMPARATIVE TEST
1. Tape two cameras together at their baseplates.
2. With a finger on each shutter release, perform the range test comparing the speeds of the two cameras rather than looking for the relationship between different speeds.

The slow speeds are the easiest to check, but in a completely mechanical camera, they will not necessarily indicate the accuracy of the high speeds - these have different speed trains and are more likely to drift. However, in an electronic camera, if most of the speed range is accurate, the rest is likely to be also.

IF THE SHUTTER STOPS WORKING 1. Check that the shutter locking control (usually located near the release) has not been moved inadvertently.

2. Check the batteries and the on/off switch if the camera is electronic.

3. Check that the film transport lever has been fully wound on.

4. Take the lens off and make sure that the diaphragm linkage is not sticking.

5. Lock up the mirror to see if the fault lies there.

6. If all the earlier steps check out, try easing the shutter blinds with your hand very gently.

7. If the camera is electronic, operate the mechanical back-up shutter. If the shutter then works, go on using it in this way until you reach a repair shop.

8. If the shutter is still jammed, put the camera away and have it repaired professionally.

IF THE SHUTTER IS INACCURATE 1. Determine whether the inaccuracy is limited to certain film speeds or is across the range. If the former, avoid the faulty speeds.

2. Next determine whether the inaccuracy is consistent or intermittent. If consistent and only mild, you will be able to compensate by resetting the film speed dial. If intermittent, stop using the camera altogether.

FAULTY LENS

Lenses are, on the whole, more accessible than the systems in the camera body, and so can be checked more thoroughly. Areas at risk are the lens surfaces, the helical screw that moves the elements for focusing and the linkage that stops down the aperture diaphragm when the shutter release is pressed. Zoom lenses have the additional complication of a mechanism that moves elements to change the focal length.

CHECKING

BASIC VISUAL CHECK 1. Check that all the lens surfaces are free from dust and grease, which will cause flare. (GO TO PAGES 124-7, FLARE.) If they are not, clean front and back elements yourself. Check again; if there is dust on inner lens surfaces, have the lens cleaned professionally.

2. Hold the lens at an angle to the light so that you can see the inside of the barrel. Look for patches of bright metal in an old lens that can cause internal flare, and for anything loose.

3. In the tropics, particularly in the wet season, look for mottled patches on the glass. If they cannot be wiped away, they are probably fungus. (GO TO PAGES 138-9, HEAT.)

WEAR CHECK 1. Look inside the barrel from each end in turn as you operate the focus ring. The elements that move should do so smoothly, without jerking or shaking. With a zoom lens, do the same with the zoom control. If the operation is not smooth, have the lens repaired professionally.

2. With the focus set at infinity, point camera and lens down toward the ground. If the focus slips forward, there is too much play. Return the lens to the manufacturer, who will relubricate it.

3. Hold the camera steady, preferably on a tripod, and work the focus ring fully backward and forward; look through the viewer as you do this. Any sideways movement of the image (usually as you start to move the focus ring) is a sign of 'backlash'. This occurs with age, but is an irritating rather than a serious problem.

APERTURE CHECK 1. With the lens off the camera, work the aperture ring. It should move smoothly, with distinct clicks at each f-stop.

2. Do the same when the lens is on the camera and the preview button is depressed.

3. Open the back of the camera and, at a

very slow shutter speed, press the shutter release at different aperture settings. If the apertures do not appear as they should, the fully automatic diaphragm (FAD) linkage may be at fault. By trying other lenses and another body, determine whether the linkage is faulty in the lens or in the body.

FOCUS CHECK 1. Looking through the viewfinder is the best basic check, provided that the viewing screen and prism are properly located. Check that the visual focus coincides with the distances marked on the lens barrel.

2. To check the focus at the film plane, open the camera back, set the shutter to B or T and leave it open; then place a small piece of tracing paper (or a spare viewing screen, ground-glass side forward) flat against the open shutter, where the film normally lies. Point the camera at a bright view; the image will be projected on the paper. This is a rough check, and will not show whether the image is pin-sharp.

IF THE FAD LINKAGE MALFUNCTIONS It may simply be twisted and a spare camera body or second lens will show you how it should look. If so, bend it very gently until it works without catching. Otherwise, take it to a professional repair shop.

IF THE FOCUS IS NOT SHARP AT INFINITY 1. If the lens is made of fluorite or rare-earth glasses, the focus settings go beyond the infinity mark intentionally, to compensate for temperature changes that affect the lens. As long as you can focus what you want by eye, there is no problem.

2. Check that, inadvertently, you have not left a close-up extension ring attached to the camera.

3. The lens elements may have been jarred out of their settings. Have the lens repaired professionally.

IF THE FOCUS IS UNSHARP ACROSS THE FRAME If the distribution of focus seems to bear no relation to distance (for instance, if part of a subject at one distance is out of focus), the mirror-box is probably twisted out of shape. This needs major professional repair.

IF THE APERTURE DIAPHRAGM IS STICKING The bearings are probably dirty or need oiling. Have them cleaned professionally. Beware of trying to relubricate the mechanism yourself - removing lens elements for access may alter a precisely calibrated focus, and lubricant must never reach the diaphragm blades.

FAULTY METER

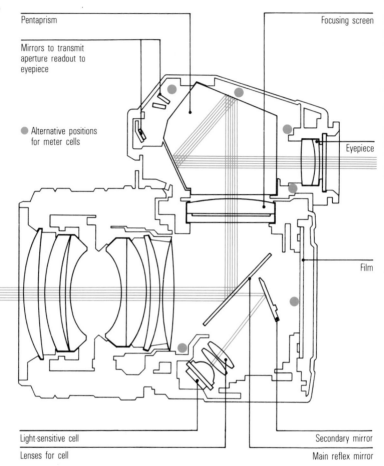

Pentaprism

Mirrors to transmit
aperture readout to
eyepiece

● Alternative positions
for meter cells

Focusing screen

Eyepiece

Film

Light-sensitive cell

Lenses for cell

Secondary mirror

Main reflex mirror

METER MECHANISM In SLR
cameras, a light-sensitive cell
measures the image at some
point inside the body. Common
places from which to take the
reading are shown by spots in
the diagram (ABOVE): from the
mirror (either reflected by it or
transmitted through it), from
the shutter blind and film or
from the ground-glass focusing
screen. In this Nikon F3, a
highly sensitive cell at the base
of the camera reads a very
small quantity of light that
passes through an unsilvered
area of the mirror. Check
which system applies to your
camera by consulting its
instruction booklet.

Most meter problems are actually ex-
posure problems, caused either by an
unusually lit subject or by operator error.
Check these possibilities first. (GO TO PAGES
94-5, HIGH-CONTRAST LIGHT; 120-3, EXPOSURE
PROBLEMS.) Genuine meter problems are
due either to system failure, which can be
power failure from the battery, component
breakdown, or a broken circuit; or to the
meter needing recalibration.

CHECKING 1. The best check for meter ac-
curacy is to know what the reading should
be. In other words, if you are familiar with
the exposure settings for different lighting
conditions, you should realize immediately
if the meter starts to malfunction.

2. Compare readings of one view
(preferably of an even, average tone, such
as a concrete wall) taken with different
meters. If they are within half a stop of each
other, they are more likely to be right than
wrong. (GO TO PÁGES 118-19, TEST PAGES.)

148

3. Compare the meter readings with the settings that are recommended for different lighting conditions given by the film manufacturer. They should correspond.

4. With the camera aimed at one view, alter the shutter speed and aperture in tandem (for example: 1/500 second at f2.8, followed by 1/250 second at f4, and so on). The meter reading should be identical for each setting.

IF THE METER DISPLAY DOES NOT WORK 1. Check that it is switched on.

2. Check the battery by cleaning and replacing it, or by fitting a fresh battery. There is a governor in the meter circuitry that cuts out when the voltage drops below a certain level (usually about 2.6 volts for a 3-volt battery).

3. Wind on and fire a couple of times - some cameras do not show a full display at the beginning of the film until the first frame is reached.

4. If there is a possibility that the camera has been wet, dry it thoroughly; there may be a short circuit. (GO TO PAGES 132-3, WATER.)

5. If none of the previous steps work, have the meter repaired professionally. Meanwhile, you can continue to use the camera by following the exposure guide packed with the film; bracket exposures for safety.

IF THE METER IS INACCURATE 1. Check that the film speed has been set properly.

2. If the camera has just been directed towards a very bright light, the meter may be 'remembering' the high exposure reading (it may even be damaged). Leave for a few minutes and run through the checking procedures.

3. If the meter is consistently inaccurate at all light levels and control settings, it needs recalibrating. Determine by how much and adjust the film speed dial accordingly (for example, if it displays one f-stop smaller than it should, it will cause you to underexpose, so halve the ASA number set). If the meter is causing overexposure, set a higher ASA number.

4. If recalibrating is needed, have it carried out by the manufacturer or a professional camera repairer.

METERING AREA The only significant variation between different through-the-lens meters is in the area of the picture that they measure while in use. It is essential to be familiar with the one that your camera uses. These are the three most common: center-weighted (1), average (2) and spot (3). Some cameras incorporate a choice of ways to meter the area, but the danger in this case is forgetting which is in use.

FILM DEVELOPING CHECK

Film faults can be caused during manufacture (rarely), in the camera, or during processing; an important part of analyzing a problem is assigning it to one of these three stages. If you process your own film, check that you take all the precautions shown here - development is full of opportunities to damage photographs.

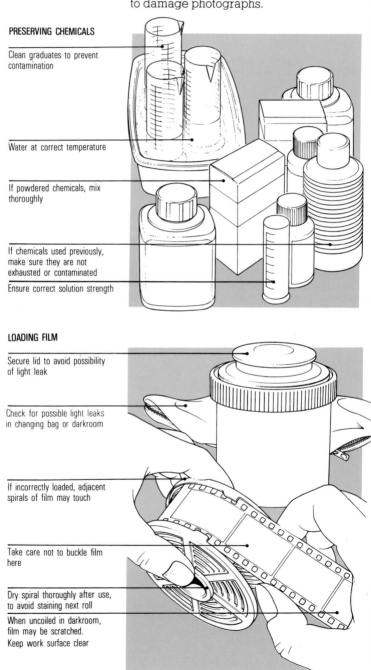

PRESERVING CHEMICALS

Clean graduates to prevent contamination

Water at correct temperature

If powdered chemicals, mix thoroughly

If chemicals used previously, make sure they are not exhausted or contaminated

Ensure correct solution strength

LOADING FILM

Secure lid to avoid possibility of light leak

Check for possible light leaks in changing bag or darkroom

If incorrectly loaded, adjacent spirals of film may touch

Take care not to buckle film here

Dry spiral thoroughly after use, to avoid staining next roll

When uncoiled in darkroom, film may be scratched. Keep work surface clear

PROCESSING

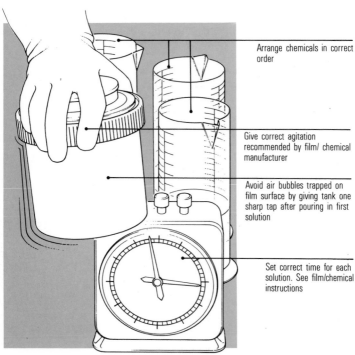

Arrange chemicals in correct order

Give correct agitation recommended by film/ chemical manufacturer

Avoid air bubbles trapped on film surface by giving tank one sharp tap after pouring in first solution

Set correct time for each solution. See film/chemical instructions

WASHING AND DRYING

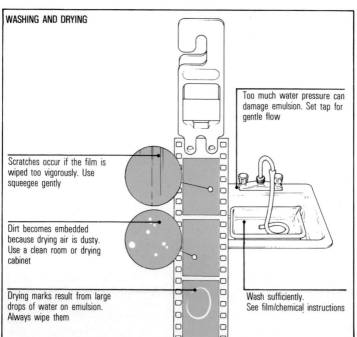

Too much water pressure can damage emulsion. Set tap for gentle flow

Scratches occur if the film is wiped too vigorously. Use squeegee gently

Dirt becomes embedded because drying air is dusty. Use a clean room or drying cabinet

Drying marks result from large drops of water on emulsion. Always wipe them

Wash sufficiently. See film/chemical instructions

RESTORING FILM

Damaged negatives can often be improved, or even restored. Given modern techniques, including retouching, virtually any blemish can be removed, although if it is serious, the effort and expense may not be worthwhile. With three layers of dye making up the film, and without the printing stage to hide small errors, transparency restoration needs to be more precise than negative work.

Nevertheless, minor faults on a large scale, such as color casts and weak contrast, are quite easy to handle if you make a copy slide. Duplicate transparencies for professional retouching are usually made on 4 x 5in (10.2 x 12.7cm) or 8 x 10in (20.3 x 25.4cm) sheet film under an enlarger on special tungsten-balanced, duplicating film. This is a skilled technique that takes time and good darkroom facilities; you might, nevertheless, consider having a duplicate made professionally before carrying out the retouching yourself. Much simpler, and in many way more versatile, is same-size slide copying on 35mm, using a machine that delivers controlled flash exposures and accepts a regular camera with daylight film. Some slide copiers use tungsten light.

PROCEDURE 1. Decide whether to work on the negative print or transparency. Negative restoration is more difficult than print retouching, and there is risk of irreparable damage to the original. On the other hand, a restored negative can be printed time after time. Some blemishes are easier to correct on a negative than on a print, and vice versa.

Unless you have considerable experience, transparency retouching is best avoided; the major difficulty, even on a large film size, is blending the work with the original image. The only two techniques that require just moderate skill (but neither is easy) are airbrushing and color

TYPES OF FILM	DUPLICATE TRANSPARENCIES	COPY NEGATIVES
Ektachrome Duplicating Film 6121 (sheet)	Enlarger	
Ektachrome Slide Duplicating Film 5071 (35mm)	Camera and tungsten light	
Ektachrome 200, with reduced processing (35mm, 120 roll)	Camera and slide copier	
Ektachrome SO-366 (35mm)	Camera and slide copier	
Kodak Professional Direct Duplicating Film SO-D15 (sheet)		Enlarger
Kodak Rapid Process Copy Film (35mm)		Camera and slide copier

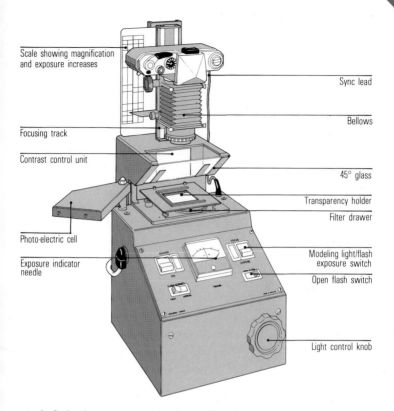

Scale showing magnification and exposure increases

Focusing track

Contrast control unit

Photo-electric cell

Exposure indicator needle

Sync lead

Bellows

45° glass

Transparency holder

Filter drawer

Modeling light/flash exposure switch

Open flash switch

Light control knob

wash. In both cases, work on large film, by making a copy if necessary.

2. Choose the technique(s). If you are unfamiliar with the technique, practice it first on an unimportant piece of film or print. If you combine more than one technique, order them so that the later ones do not affect the earlier ones (a bleach bath, for example, will wash away pencil retouching). Generally, try to follow this sequence: redevelopment baths – chemical baths – knifing and abrading - dye – watercolor – pencil.

3. If necessary, make an enlarged copy negative or transparency. 35mm film is too small for any detailed technique, and best treated only with chemical baths or dyes. Make copies on 4 x 5in (10.2 x 12.7cm) or 8 x 10in (20.3 x 25.4cm) film.

When making a copy negative, remember that the copying film is positive (that is, it produces a negative directly from a negative) so that exposure and development times work the opposite way to a print - less light from the enlarger produces a denser copy negative, while extended development lightens the negative.

MAKING COPIES In many restoration procedures, the first step is to make a copy, either to insure against irreversible mistakes, or to have a larger sheet for intricate work. Two common methods are to use a regular enlarger or a slide copier (ABOVE). Slide copiers are useful for many restoration techniques, including increasing contrast, cropping the picture to avoid a blemish, altering the overall color cast, altering color in one part of the picture (use filters for both these), altering the brightness in different parts of the picture, and brightening or darkening overall. Use slide duplicating film; if unavailable, use daylight film and reduce the development (high contrast is a common problem; the process tends to augment contrast).

RESTORING FILM/2

INTENSIFICATION A weak, underexposed negative produces a flat, grey print lacking in contrast (1). A hard paper grade may help; for more improvement treat the negative with an intensifying solution. This adds density to the existing silver deposits, and can increase the contrast by two or three stops (2).

REDUCTION An overexposed negative usually contains highlights so dense in silver that they cannot pass sufficient light to the print. The result is featureless bright areas (3). A reducing solution dissolves some of the silver in the negative. Some formulas maintain contrast; others increase it (4).

TECHNIQUE	EFFECT
INTENSIFYING	Increases the density of the image. Usually increases contrast as a side-effect
REDUCING	Weakens density by dissolving parts of the image. Some reducers increase contrast; all increase graininess
COPY NEGATIVE/ CONTRAST CHANGE	Brightness and contrast can be varied according to exposure and development times
COPY NEGATIVE/SHADING	Alters tonal distribution across image
COPY SLIDE	Tends to increase contrast. Can be used to alter brightness and colors
PRINTING MASK	A light density copy that is combined with the original to increase or decrease contrast
PRINT CONTROLS	Varies brightness selectively (and color if printing in color)
LOCAL BLEACH	Reduces density drastically
LOCAL DYE/COLOR WASH	Adds density and color very selectively and precisely
KNIFING	Removes density: particularly useful for small spots
ABRADING	Removes density, but rather crudely
DETAILED BRUSHWORK	Depends on skill and technique used: can alter image substantially
AIRBRUSH	Major illustrative changes possible: shading effects very realistic and blend well with photographic images
PENCIL	Shading and lines, although crude

2

| CAN BE USED ON: | | | NEEDS LARGE COPY | DIFFICULTY RATING |
NEGATIVE	TRANSPARENCY	PRINT		
■				EASY
■	■			EASY
■				MODERATE
■			■	MODERATE
		■		MODERATE
■		■		DIFFICULT
■		■		MODERATE
■	■			MODERATE
■	■	■	■	MODERATE
■	■		■	DIFFICULT
■	■	■	■	MODERATE
■	■	■	■	DIFFICULT
■	■		■	DIFFICULT
■			■	DIFFICULT

SHIPPING/CUSTOMS/X-RAYS

PROBLEM SUMMARY: Because of its value, photographic equipment is given special attention by customs officials and regulations are often very restrictive. Exposed film is always at risk if it is not with you; sufficient exposure to X-rays will harm film.

SHIPPING Film is at its most vulnerable after it has been shot but before processing. Not only is it in its least stable condition (that is, carrying a latent image but no longer factory-sealed) and needs to be processed as quickly as possible, but as the days pass and the shot rolls accumulate, this film becomes more and more valuable to the photographer working abroad.

The cardinal rule is to keep film under your own control, so that you know what the storage conditions are. However, if the trip is longer than a few weeks, or the storage conditons are hot and humid, the film should be sent home quickly before it deteriorates. In addition, professional photographers often have deadlines that can only be met by shipping the film immediately.

DECIDE WHERE TO PROCESS The first, crucial, decision in whether to have the film processed at a known, reliable lab at home, or to risk local processing. This risk may be small if you are in a city with an established photographic market, but high in many remote areas. If you are shooting Kodachrome, local processing may be impossible, as there are only a limited number of Kodak labs in the world that can handle this film.

If you decide to have the film processed locally, look for a lab that handles the film of local professionals. Better still, ask a local professional photographer to recommend a good lab. Run a test roll through first to check the quality of the processing. The advantage of processing locally and then shipping the developed transparencies or negatives (which you will still need to do if you are a professional with a deadline to meet) is that you can be certain of the results, and you will be able to retake if necessary. You can also edit the pictures so that a set of near-duplicates of those that are sent remains with you.

MAIL Surprisingly little mail is ever actually lost, but it is not the fastest method, nor is it totally secure even if the parcel is registered. Packets are not given special storage treatment. Film should be sent registered to an address where you know

someone will receive it (or delivery will be delayed). Fill in the customs declaration to read 'Exposed photographic film. No commercial value' (or it may be held by customs for payment of duty). Wrap film in a lead-lined protective bag and mark 'Film. Do not X-ray'.

AIR FREIGHT On most occasions this probably makes the best compromise between security and expense. Agents are usually located at airports, and it is generally best to go there to oversee the documentation, although most will collect. As with mailing, pack the film in a lead-lined bag, and have the agent type on the airway bill: 'Unprocessed film. Keep cool. Do not X-ray. Do not delay.' Keep a copy of the airway bill; for even greater safety, telephone its number to the person receiving the film at home.

COURIER This type of service is basically personally attended air freight; requirements are the same documentation. It can be very expensive indeed, except on popular routes such as between New York and London.

CUSTOMS One of the difficulties of foreign travel is clearing cameras, lenses and film through customs. As valuable commodities, they always have duty levied on them if they are being imported and are only exempt if they are personal effects. Unfortunately, what counts as personal effects is often limited to the equipment that a very casual amateur would carry; customs allowances in most countries have not kept pace with what most serious photographers now carry.

ABOVE One method of avoiding import restrictions and possible duty is to suggest to the customs official that, rather than charge duty on an excess quantity of film, he enter the total in the passport. This is an unalterable check that can be verified when the passport is shown on leaving the country.

Added to this general problem are the idiosyncracies of certain countries and individual officials. As a rule, expect to encounter problems if you carry much more than one camera, three lenses and a handful of film. However, customs officials are generally lenient if you strike the right attitude.

ENTERING FOREIGN COUNTRIES Even if you are carrying a quantity of equipment, it usually does not pay to appear to be a professional, unless special arrangements have already been made. In some countries, professional equipment is subject to duty and other restrictions, while in others it simply attracts attention.

Carry a list of your equipment, but only show it if asked. It will make you seem organized and efficient, which may divert the attention of an inquisitive official.

Play down the value and newness of the equipment. Carry receipts to prove the origin of the cameras and lenses when you return home, but abroad show the list.

The purpose of customs regulations is to prevent you selling the equipment in the country without paying the duty. Anything you can offer to prove that you will not do this should help. For instance, in real difficulty, suggest that a list of the equipment and film be entered in your passport for checking when you leave.

In the worst instance, you may have to choose between paying duty (which should be refundable later) and leaving the equipment in custody. In either case, get a receipt.

RETURNING HOME Your own national customs will not necessarily be more lenient or reasonable than those abroad. The crucial question, however, is always whether you have paid duty on what you are carrying. The best proofs are your receipts - always carry them with you or photocopies of them. If you have imported cameras in the past, include the customs receipt to show that you have paid duty.

X-RAYS Security checks are hard to avoid when traveling by air, but they are a real hazard to film - all the more serious because, in order to speed up traffic, most airports play down the effect. If you have any doubts about how well the X-rays from these machines can penetrate, take a look at the operator's viewing screen the next time you fly.

X-rays are on the same scale of radiation

as light, but have a much shorter wavelength and are, of course, invisible. If they strike film, they have the same effect as light - they cause fogging. Most airport X-ray machines are designed to give such small doses that the effect of one exposure is well below the threshold needed to fog film. However, other X-ray machines give damagingly high doses; as a passenger you have no way of knowing the level. In any case, a number of passes through a low-dosage machine may take the radiation over the threshold, and it is easy for this to happen if you take several flights in one trip.

A few countries, notably the United States, have government regulations controlling the levels of radiation. In the United States, the machines used for checking carry-on baggage are set to one milliroentgen, which will do no harm. Nevertheless, after about five passes the film might show some slight fogging. Many countries, however, are less scrupulous about doses.

EFFECTS A strong X-ray dose acts on film like a short exposure to light in the darkroom - it fogs the film overall. In addition , as X-rays are slowed down by metal, a 'shadow' of part of the film cassette may be thrown across the film.

PRECAUTIONS The best precaution is not to let the film pass through an X-ray machine and ask instead for a hand inspection. The problem is that it is not always possible to guarantee this. In some airports the security staff may just refuse; by the time this becomes apparent, there is usually nothing you can do. In the United States, however, federal regulations give you the right to a hand-inspection.

● If you know for certain that you can have the film inspected by hand, carry it with you.

● If you are not certain, pack it in a special X-ray-proof lead-lined envelope (sold in professional camera shops for this purpose). This will resist the exposure to a low-dosage machine.

● Checked baggage is hardly ever X-rayed, so packing film in a suitcase is worth considering. However, although the risk is remote, if checked baggage is X-rayed, the dose is likely to be high.

● In asking for a hand-inspection, be polite rather than argumentative. Appeal to reason: 'The film has already had several doses' or 'This is technical film'.

DARKROOM PROBLEMS

As processing and retouching are the final stages of photography, a variety of different problems tend to accumulate. Because, in theory, just about anything is possible at this stage, including full-scale retouching, many problems that could be cured, or even avoided, earlier on are left to be dealt with here. In practice, special darkroom and retouching techniques are quite demanding and time-consuming, so that shunting a problem down toward this end of the photographic process is often not the best use of effort.

Nevertheless, small miracles are possible even with seriously blemished images; they simply need time, skill and only a moderate amount of equipment. Retouching, which is the ultimate set of techniques that you can apply to a photograph, can range from simple spotting to tidy up a print, to what can virtually amount to original illustration.

The techniques and processes involved in printing, toning and retouching can introduce new faults themselves. This section, therefore, covers not only how to use the darkroom to solve problems generated earlier, but how to detect, correct and avoid the problems that darkroom procedures can create. Compared with other stages in photography, the darkroom makes detecting problems moderately easy – faults can be spotted almost as soon as they are made and the source of a problem is usually within arm's reach.

PRINT FAULTS

If a finished print is blemished, first check the negative or transparency to make sure that the fault does not lie there (GO TO PAGES 104-15, FAULT-FINDER). Having eliminated that stage as the cause, compare the print with the examples shown here. All display faults that are likely to occur during enlarging, contact printing, processing or drying.

Because print problems can usually be seen immediately, finding the cause and correcting it is normally straightforward. Nevertheless, always examine any print thoroughly and under bright lighting after processing; a casual inspection under a red safelight can easily miss small-scale errors.

PRINTING FROM TRANSPARENCIES Direct prints from color transparencies are made using a reversal process. As a result, print faults have the opposite tones to those shown in these examples. For instance, dust specks appear black rather than white and fogging lightens the paper rather than darkens it.

1: Dust
SYMPTOMS Small, sharply defined but irregular white spots, most obvious on dark areas.
CAUSE Dust on negative.
TREATMENT Keep interior of enlarger clean. Examine each negative before printing, holding it at an angle to the light from the enlarger. Remove with compressed air or brush. Give antistatic charge to negative to prevent resettling of dust.
CHANCES OF RESTORING PRINT Good. Spot with fine brush and dye or process black.

2: Hair or fingerprint

SYMPTOMS Thin white curved line; vague pattern of closely-spaced lines.

CAUSE Hair on surface of negative; grease deposits from fingerprints.

TREATMENT Examine negative before printing. Remove hair with compressed air or brush. Wipe fingerprints if on shiny side of negative; if on emulsion side, rewash. Only handle film by its edges.

CHANCES OF RESTORING PRINT Moderate. Retouch with brush and dye or diluted pigment.

3: Misaligned negative

SYMPTOMS Angled dark edges.
CAUSE Negative not square in carrier.

TREATMENT Straighten negative; adjust cropping by changing enlargement or easel mask.

CHANCES OF RESTORING PRINT Trimming the print is the only practical solution. Otherwise, display by cutting a paper or card mask and mounting this over the print.

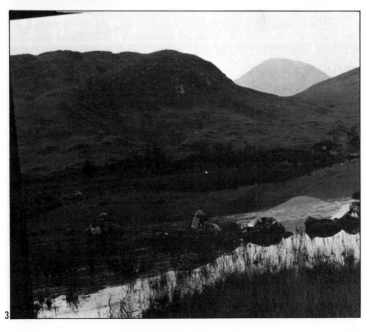

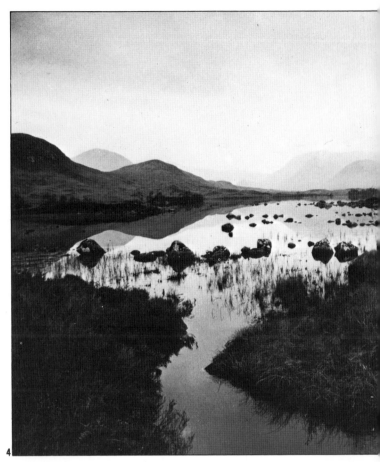

4

5

4: Wrong condensers

SYMPTOMS Gradual darkening or lightening towards the corners.

CAUSE If the enlarger has a condenser head, and is adjustable, either the wrong condensers are fitted for the lens in use, or the lamp position needs to be readjusted. However, check first that the fault does not lie in the negative. (It could be a wrong lens shade or else the natural effect of a wide-angle lens.)

TREATMENT Adjust condensers, or shade/print-in corners during printing.

CHANCES OF RESTORING PRINT Moderate. If corners are featureless, such as sky, airbrush with pigment or dye. Alternatively, apply dilute bleach.

5: Soft focus

SYMPTOMS Image soft overall.

CAUSE Lens not focused sharply. Distinguish from enlarger shake.

TREATMENT Check focus with the lens at full aperture. For the greatest precision, use a focus magnifier.

CHANCES OF RESTORING PRINT None.

6: Lens tilted

SYMPTOMS Differential focus (focus drifts across print from sharp to soft).

CAUSE Print not parallel to negative. In an enlarger that has the facility for movements to be made to control image distortion, the head or lens mount may be tilted.

TREATMENT Check enlarger movements; straighten and tighten.

CHANCES OF RESTORING PRINT None.

7: Enlarger shake

SYMPTOMS Blurred image, but different from soft focus in that, under a magnifying glass, edges appear double.

CAUSE Movement during exposure, probably due to vibration but possibly because negative 'popped' due to heat or because print was touched during shading or printing-in.

TREATMENT Check firmness of enlarger mount.

CHANCES OF RESTORING PRINT None.

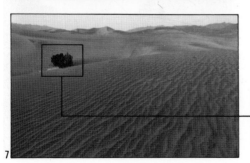

8

8: Excessive printing-in

SYMPTOMS Grey patch in light area that has received burning-in treatment.

CAUSE Too much exposure. There is a limit to the amount of burning-in that is possible in a dense area of the negative. Beyond this, the paper fogs.

TREATMENT Reduce burning-in time.

CHANCES OF RESTORING PRINT Quite good. Retouch with airbrush or brush with pigment. Alternatively, use dilute bleach with swab or brush.

9

10

9: Light leak
SYMPTOMS Greyness covering all
or a large area of the print,
and sometimes the borders.
CAUSE Fogging due to light leak
somewhere in the darkroom. If
the light leak occurs after the
enlarger exposure, the greyness
will extend to the white
borders of the print.
TREATMENT Check the
lightproofing.

CHANCES OF RESTORING PRINT None.
10: Paper upside-down
SYMPTOMS Very pale, mottled,
unclear image.
CAUSE The printing paper was
placed with the emulsion face-
down in the enlarging easel.
TREATMENT Become familiar with
the different textures of the
emulsion and base sides of the
paper.
CHANCES OF RESTORING PRINT None.

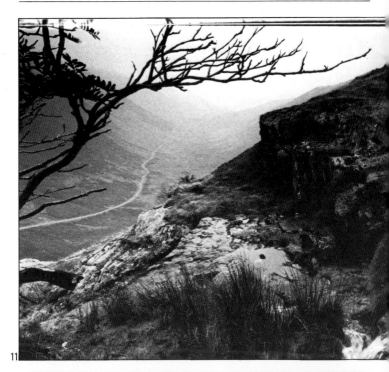

11

12

13

14

11: Poor cropping
SYMPTOMS Dark line at edge of print.

CAUSE Image not cropped in closely enough; rebate of negative included in picture.

TREATMENT Examine cropping carefully; adjust easel marks.

CHANCES OF RESTORING PRINT Trim print, or display by mounting behind cut-out.

12: Fixer stains
SYMPTOMS Streaked discoloration on right.

CAUSE Probably contaminated fixer or insufficient fixing time.

TREATMENT Use fresh fixer in clean graduate and tray. Follow manufacturer's instructions for fixing time.

CHANCES OF RESTORING PRINT None.

13: Misaligned paper
SYMPTOMS Picture at angle to paper.

CAUSE Paper not placed straight in the enlarging easel.

TREATMENT Take care to place paper in guide slots.

CHANCES OF RESTORING PRINT Trim print, or display by mounting behind cut-out paper or card mask.

14: Wrong paper grade
SYMPTOMS Tonal range of picture too small (grey, flat image) or too great (too much contrast).

CAUSE Paper grade not matched to negative.

TREATMENT Examine negative and choose paper grade accordingly. Grades range between soft and hard (0 to 4 or 5). Use a soft grade for a high contrast negative, a hard grade for a weak negative. Also consider printing controls.

CHANCES OF RESTORING PRINT Poor. Make a copy print.

169

MAKESHIFT DARKROOMS

PROBLEM SUMMARY: A darkroom should be dark enough for the materials you are working with and roomy enough for the job at hand.

A full-scale, well-equipped darkroom is a luxury which few people can afford and which demands a great deal of space. Nevertheless, for the sake of some temporary inconvenience, darkrooms can be adapted from a surprising variety of rooms. Makeshift darkrooms are valuable for occasional developing and printing, and for emergencies; for example, when a roll of film breaks off in the camera. (GO TO PAGES 172-3, LIGHTPROOFING.)

ADAPTING A STUDY Steps in printing that need running water do not need to be in darkness, so that even a 'dry' room can be used as a darkroom; simply carry fixed prints in a splash-proof container (even a bucket) to the bathroom or kitchen for washing. First lightproof the room, then make sure that there is sufficient and convenient working space. Keep chemicals away from the enlarger area to avoid splashing.

ADAPTING A BATHROOM Although they are less convenient for working than other rooms, bathrooms do have plumbing and occasionally are windowless. Place a thick board over the bathtub to create the main working surface, but leave a gap at the tap end so that you can reach down to the washing tray underneath. Put the enlarger

CONVERTED STUDY OR OFFICE
Arrange developer, stop bath and fixer trays temporarily on a protected work surface, at a distance from anything that can be harmed by chemical splashes. Use a bucket, or other splash-proof container, for carrying fixed prints to wash in the bathroom or kitchen sink.

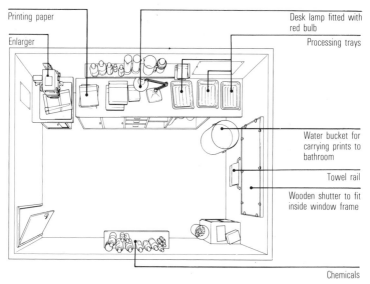

Printing paper

Enlarger

Desk lamp fitted with red bulb

Processing trays

Water bucket for carrying prints to bathroom

Towel rail

Wooden shutter to fit inside window frame

Chemicals

at one end and next to it the processing trays (if the bathtub is short, place the fixer tray underneath). The obvious problem is chemical splashing close to the enlarger; place a vertical card as a shield for extra safety. Be very careful with the electricity supply to the enlarger; it is safer to run the lead to a socket outside the bathroom than use one inside.

ADAPTING A CLOSET Small closets are inconvenient, but can be used as a last resort. Make sure that you have enough room to stand in a working position. Because everything is close together, take special care to avoid splashing and paint the area around the enlarger matt black in order to prevent reflections fogging the prints. Such fogging will degrade the image overall.

CHANGING BAG A changing bag - a double-lined black bag with sleeves - can be used anywhere, and provides sufficient protection for loading film or paper into a developing tank, or for loading and unloading bulk and sheet film, or for unloading a jammed camera. Make sure that the inside is free from loose lint, which can easily adhere to the film through static electricity.

In an emergency a thick jacket can be used as a bag. Wrap elastic bands around the sleeves and a blanket or other lightproof cloth around the middle. Use in semi-darkness only; it is not perfectly lightproof.

CONVERTED BATHROOM The size of the bath determines how much of the processing sequence can be carried out on the baseboard. There are unlikely to be many available working surfaces; here both fixative and wash are underneath the board. Bathrooms, when sizeable, are convenient because of handy washing facilities.

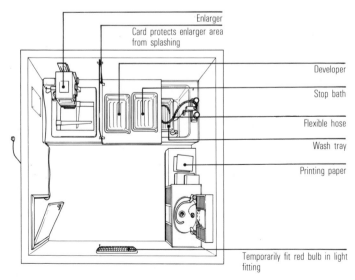

Enlarger

Card protects enlarger area from splashing

Developer

Stop bath

Flexible hose

Wash tray

Printing paper

Temporarily fit red bulb in light fitting

LIGHTPROOFING

PROBLEM SUMMARY: All films and printing papers have to be handled in some degree of darkness; careful checking avoids the risk of fogging.

All regular light, including daylight and any type of interior lighting, fogs photographic emulsion. Some materials, however, are insensitive to certain wavelengths and can be handled under a dim, colored safelight. The first priority is to darken the room; the second is to install the right safelight for the emulsion.

PROCEDURE: 1. Lightproof the room. A windowless room is the easiest, but if there are windows, seal them from light by using either a special lightproof blind from a photographic store, or wooden shutters cut to fit and sealed at the edges. Doors are simpler to seal, particularly if they open onto a hallway that can be kept fairly dark. Use rubber flaps or black foam cushioning strips. In an emergency, roll a towel up against the lower part of the door.

2. Check the lightproofing. Before setting up a safelight, check that the room is dark enough. Take a sheet or strip of whatever emulsion you will be working with and lay it face up on a working surface with a solid object partly covering it. Leave it for the amount of time that under working conditions it would normally be out of a container (say, three or four minutes for black-and-white printing paper, half a minute for film, one minute for color paper). Process it normally. If you can detect even a faint silhouette of the object that was on top of it, the room is not dark enough.

3. Install the safelight. Choose the right color of cover for the lamp and fit the safelight so that it illuminates the enlarger and developing tray. Purpose-built safelights are best, but you can also convert an existing desk lamp simply by fitting a red bulb (but make sure that it is red right to the base of the socket).

4. Check the safelighting. Even the recommended color of safelight can fog film or paper if too bright or too close. Use the same checking procedure for lightproofing.

EMERGENCY CHECKLIST If you want to create a darkroom at a moment's notice, take these lightproofing steps:
1. Choose the darkest room available, such as a closet or a hotel bathroom.
2. Use blankets or towels to seal gaps from inside.
3. Switch off hallway lights.
4. Wait until night-time.
5. As a rough check, wait 10 minutes for your eyes to become used to the dark and then move your hand in front of your face. If you can see it, the room is not dark enough to expose film emulsion unless you use a changing bag.
6. To make an emergency red safelight, stick rubylith tape over a flashlight.

SAFELIGHT COLORS With some types of photographic paper and film, a colored safelight may be used in the darkroom.
1. Regular black-and-white bromide paper: orange.
2. Panchromatic bromide paper (for black-and-white prints from color originals: preferably none, but dark green is possible.
3. Color paper: none.
4. Regular black-and-white film: none, but in an emergency, use dark green with a 25-watt pearl lamp at least 7ft (2m) away and shining indirectly for short periods.
5. Black-and-white duplicating film: red.
6. Line film: red.
7. Color film: none.

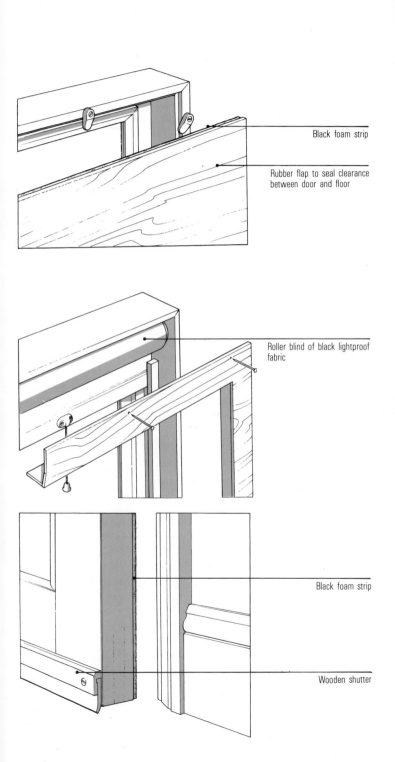

Black foam strip

Rubber flap to seal clearance between door and floor

Roller blind of black lightproof fabric

Black foam strip

Wooden shutter

ENLARGER MAINTENANCE

PROBLEM SUMMARY: Enlarger malfunction, either mechanical or optical, is a common source of print faults and is most likely if the enlarger is moved regularly. It is best to leave it set up in one corner of the room if you can.

Enlarging is a stage in photography where pictures can be improved and refined, yet faults are as likely here as at any other time, and may easily go unnoticed. Defects in a print are often blamed on the picture-taking when a thorough check of the enlarger may reveal mechanical or optical faults. Before printing, especially if it has been some time since the enlarger was used, make an inspection, following the checklist.

INSTALLING THE ENLARGER A permanent installation is best; constant movement and dismantling can easily cause damage and misalignment. Do not try and judge alignment by eye; measure it by using these methods:

● **CHOOSE A SOLID SURFACE** An enlarger must be free from vibration. Avoid surfaces that wobble or bend. The top of a cabinet file or trunk is better than a wall-bracketed shelf. A block of seasoned wood 1in (2.5cm) thick is a useful base if you have no suitable free-standing surface.

Illuminate a negative at maximum enlargement and watch the projected image for movement while tapping the surface firmly and while someone else slams doors and walks heavily around the house. Four hard rubber feet under the base should absorb vibrations.

● **LEVEL THE BASE** The best makes of enlarger have four adjustable leveling screws under the baseboard. Place a two-way spirit level on the baseboard and adjust the screws to center each bubble in turn. Remember to lock the screws afterward.

● **ADD EXTRA CLAMPS** If possible, attach the top of the column to the wall behind. This adds stability.

MAINTENANCE CHECKLIST
Check for the following faults:
1. Dirt on the lens. Causes flare and vague dark spots when stopped down. Clean.
2. Dirt on condensers or filters. Causes soft-edged dark spots on print at small apertures. Clean with compressed air, then cloth.
3. Wrong condensers. If the enlarger has changeable condensers, make sure they match the focal length of the enlarging lens.
4. Unsteady baseboard. Causes double or blurred image. Adjust base screws or insert a wooden wedge.
5. Baseboard not parallel with negative. Causes soft focus on one side of the print. Check by placing any negative containing sharp edge-to-edge detail in the carrier and projecting. Examine focus with a focus magnifier. Misalignment may be evidence

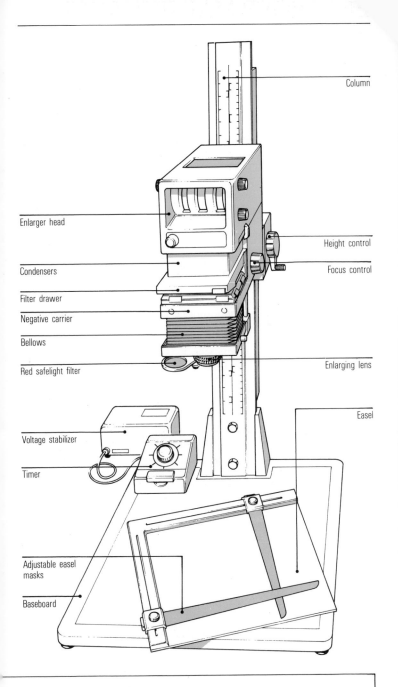

Column

Enlarger head

Height control

Condensers

Focus control

Filter drawer

Negative carrier

Bellows

Red safelight filter

Enlarging lens

Easel

Voltage stabilizer

Timer

Adjustable easel masks

Baseboard

of a bent column or twisted negative carrier.
6. Torn bellows or gaps in enlarger head. Can cause slight fogging of print. Repair or seal with black tape.
7. Condensers badly adjusted. Causes darkening towards edges of projected image.

Check evenness of illumination without negative in carrier.
8. Wrong enlarging lens. If lens does not cover negative, illumination and image quality fall off toward the edges of the projected image.
9. Focus gears slip. Causes soft focus. Tighten locking screws

or relubricate.
10. Chipped easel marks. Can cause slight fog patches on print by reflecting light. Paint matt black.
11. Column loose or bent. Causes double or blurred image, or soft focus on one side of print.

PRINTING SPOILED NEGATIVES

PROBLEM SUMMARY: If a damaged negative cannot be restored, it may have to be printed using special enlarging techniques.

Some film faults can be cured, or their effects alleviated, by a number of printing tricks. Even if these make only a slight improvement, they will make retouching easier later. Of the techniques described here, shading and printing-in are described more fully on pages 178-81.

PRINTING WET Use a glass carrier as a sandwich for the negative. Either wet the negative thoroughly in water, or coat the scratched side with glycerine evenly. In either case the liquid will fill in the scratch and, by refraction, reduce its effect on the print. Good for deep scratches.

EXTRA DIFFUSION The more diffuse the light source, the less prominent the shadows from very small details. Fit one or more sheets of tracing paper under the lamp in the enlarger head in order to diffuse the light. Good for light scratches, particles of fine embedded dirt.

FILM MASKING To decrease contrast in a negative, make a contact copy onto another piece of negative film material, but with very little exposure so that the developed image is very weak. The mask will be the reverse of the original - in other words a positive image. Then, sandwich it in register with the original and print; the resulting combination will have a reduced contrast. The chief problem is register; if this is only slightly out, the effect will be obvious. To overcome this, make the copy with a thickness of clear film in between, so that the mask is slightly soft. For even less

BELOW Use glycerine or water on a sheet of glass to bathe the emulsion of a negative during printing. By filling scratches, this reduces their effect on the image. Clean and dry the negative carefully after use; the emulsion will be soft.

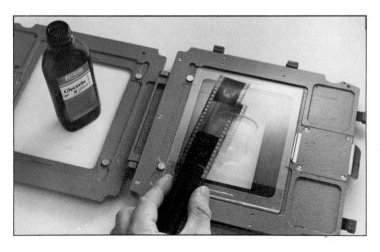

sharpness, you can also print the original and mask with a piece of clear film between. Establish exposure and development of the mask by trial and error; use the enlarger as a light source.

To increase contrast in a negative, use the same principle, but use a negative instead of a positive mask. In other words, make a weaker duplicate of the original, and print the two as a sandwich. To make a copy negative, contact-print using direct duplicating film which produces a negative from a negative in one step; alternatively, with ordinary negative film, make a positive first and then a negative from this. Use the same techniques as above.

Film masking is effective but complicated, and is easiest to register with large film. Good for high contrast, low contrast, fog patches.

SMALL APERTURE Most enlarging lenses are sharpest at about two or three f-stops less than full aperture, and this is the normal setting for printing. However, if the film will not lie flat, use the smallest aperture for a greater depth of field. Good for buckled or creased film.

SHADING AND PRINTING-IN These regular print controls - giving more or less light to specific parts of the print by placing your hands or shaped pieces of card in the beam of light - are valuable not only for fine-tuning prints but also for concealing blemishes. They are less precise than film masking and not so easy to repeat accurately, but they are simple and take little preparation. Good for simple fogging, high contrast, ill-defined blemishes. (GO TO PAGES 178-81, PRINT CONTROLS.)

BELOW A diffuse light source reveals marks, pinholes and scratches to a lesser degree than a small intense lamp. With a condenser head, diffuse the light with sheets of tracing paper cut to fit in the filter tray above the negative.

PRINT CONTROLS

BLACK-AND-WHITE Spectacular changes can be made to the printing potential of a negative simply by controlling the light from the enlarger. By placing any appropriately shaped object in the beam from the enlarger lamp, the pattern of light can be altered so that some parts of the image receive more light and others less.

Used purely as a treatment for faults, such as flare fogging one side of a negative, print controls can sometimes make retouching unnecessary. Their most common use, however, is to print all the details in a high-contrast negative. Although a soft paper grade can help up to a point, most negatives are better if printed on a normal grade of paper that keeps the overall appearance of the image crisp, with rich shadow blacks and bright highlights. It is also possible to have the best of both worlds by using grade 2 or 3 paper but balancing the contrast by giving shadows less light and brighter areas more. Even when a negative has no defects such as excessive contrast, print controls can be used to alter the character of the image.

SHADING AND PRINTING-IN These are two complementary techniques. Shading, also known as dodging, holds light back from an area of the print, making it lighter than it would normally be. Printing-in, also known as burning-in, adds extra light to specific areas, darkening them. Use whichever is more convenient for the shape, size and position of the part of the print that you want to alter.

The simplest way of working out the procedure for any particular print is to make test strips and decide which exposure time gives the best results for different parts of the image. Then make one basic exposure, shading the areas that need less light. Afterward make an extra exposure just for the areas that need more light. The light pattern will vary in complexity according to the negative.

EQUIPMENT Anything that casts the right shape of shadow will do; the tools used in shading and printing-in are usually a matter of personal preference. Hands, pieces of black card on wire, holes in black card and shapes painted or stuck onto glass can all be used. If the card, which should be black underneath to prevent fogging by reflected light, is white on top, the area you are shading or printing-in can be judged more accurately.

SHADING TOOLS To hold back light from enclosed areas of a photograph, such as a face or a doorway, make a shading tool by taping a small piece of black card to the end of a thin rod. The card does not have to be cut to an exact shape, because in use it is moved constantly over the print to soften the edge of the shading. A few cut cards such as these will be sufficient for most shading work.

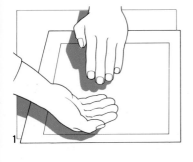
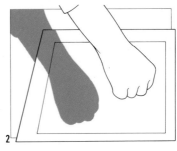
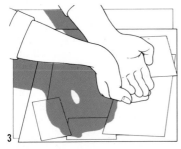

COLOR This demands more care and precision than black-and-white printing, but it also offers more scope for altering the image. Not only can shading and printing-in be used in exactly the same way but, by using filters, the colors as well as the tones can be altered in specific areas of the image. Color negatives behave as black-and-white negatives do, but shading and printing-in have to be reversed for color transparencies that are being printed directly. For example, to darken a sky when printing from a negative, you would give extra exposure above the horizon line; with a transparency you would need to give the sky less light. When altering colors, to make a face appear less red when printing from a negative, the solution would be to shade that area with a green filter (the opposite of red); by contrast, if you were printing the same picture from a transparency, you would need to use a red filter over the face.

Color control adds to the complexity of the technique; assess the test print carefully. It may help to sketch the pattern of lighting and filters. The choice of filters between color negatives and transparencies may seem confusing, but you are only likely to be doing one at a time. Use filters as you would use pieces of card to alter tones, holding them above the print and moving them constantly to prevent definite edges.

USING HANDS For shading broad areas and for printing-in, hands are sometimes the most useful of all tools. By flexing and altering their shape as well as moving them over the print, complex and subtle results are possible (1, 2). When printing-in, be careful not to allow light to spill around the edges of the hands - raise them to cover a larger area or surround the eges of the paper with black card (3, 4).

PRINT CONTROLS/2

PRINT CONTROLS/COLOR	PRINTING FROM COLOR NEGATIVE
NO COLOR CHANGE	Print-in with extra exposure through hole cut in large card.
NO COLOR CHANGE	Shade during basic exposure with shading tool
NO COLOR CHANGE	Print-in with extra exposure. Mask remainder
NO COLOR CHANGE	Shade during basic exposure
5. ENHANCING A PALE COLOR	Make second exposure to print-in the desired area, using shading tools to mask off the remainder of the print. During this second exposure, add extra filter(s) as indicated: To enhance yellow add blue filter magenta green cyan red blue yellow green magenta red cyan
6. CORRECTING A COLOR	During the basic exposure, shade the area to be corrected with a filter of the same color. Then to keep the shadow density the same, make a second exposure, shading off the remainder of the print, also using the same filter
	To correct yellow use yellow filter magenta magenta cyan cyan blue blue green green red red
SHADOW COLOR	During the basic exposure, shade the area to be corrected with a filter of the same color. Make no other exposure; this shading will reduce shadow density
8. CORRECTING A COLOR	Do as (6) above, but lengthen the time of the second exposure

Shade during basic exposure with shading tool (shaped card on wire)

Print-in with extra exposure through hole cut in large card

Shade during basic exposure

Print-in with extra exposure. Mask remainder

Shade the pale area during the basic exposure. Then make a second exposure just for this area (shading the remainder), with the following filter(s):

To enhance yellow add yellow filter
magenta	magenta
cyan	cyan
blue	blue
green	green
red	red

During the basic exposure, shade the area to be corrected with a filter of the opposite color (see below). To maintain shadow density, shade the area with the same filter for a second exposure, masking off the remainder of the print

To correct yellow use blue filter
magenta	green
cyan	red
blue	yellow
green	magenta
red	cyan

Do as (6) above, but make no second exposure

DYEING AND TONING

Color can be added to a black-and-white print by bathing it, by spraying it with an airbrush, or by using a swab or brush. By combining these techniques skillfully, the result can come close to a full color print. Toning can add an unusual or period character to the image; dyeing adds color irrespective of what lies underneath. Both can be applied to specific areas rather than to the entire image, although partial toning is difficult to do well. Toners have the greatest effect where the silver image is at its most dense, whereas dyes are most obvious in the lighter areas of the print that have least silver. In this way, toners and dyes complement each other, and if you plan to color a black-and-white print fully, use both techniques.

TONING A variety of toners is available commercially but all work by replacing the developed black silver in the print. The most common toner is sepia. The first solution bleaches the image to a pale straw color and the second tones the bleached parts brown. Some depth and partial toning can be created using a dilute bleach (about one part bleach to 20 parts water) and withdrawing the print before the deepest shadows have been bleached out; on toning, these unbleached parts will be black.

Gold toner is simpler to use but more expensive. It is a single-solution toner; subtle colors depend on the type of emulsion (silver bromide or chlorobromide) and on the time that the print is left in the bath. An initial soak in a sulphide bath gives a more brown effect.

Multi-toning kits, that use color couplers, give a wider choice of results. The principle is the same as film processing, with the color coupler(s) of choice being added first to the color developer. The print is bleached, washed and then color-developed. For brighter but lighter color results, the silver can' be removed by a final silver-bleach if desired.

With all toners, follow the packed instructions carefully. Experiment by all means, but the processes do vary.

DYEING Dyes, available in a wide variety of mixable colors from several manufacturers, differ from toners in that they soak into the emulsion and paper whether there is an image or not.

Photographic dyes are water-based, and, as a result, are slightly soluble even after they have soaked into the emulsion,

particularly immediately after use. This makes it possible to reduce mistakes during application by washing the print, but it also makes it important not to leave any wet bath process (such as toning) until after the dyeing. Tone first, then dye.

To blend a dye into the image, first wet the print so that the dye will spread slightly; otherwise it will leave distinct edges which are very difficult to remove, even if the dye is pale. If, on the other hand, you are dyeing a precisely defined area, leave most of the print dry and dampen just the area to be retouched with a brush.

The most common mistake in dyeing is to apply too much at one time; as the color dries, it is likely to be uneven, and show brushmarks. Slow though the process may be, the best way of applying dye is to use dilute color and paint it in one small wash at a time; each application should be too pale to notice at the time, but after several you should start to see the color build up.

Swabs and brushes are the most common means of applying dye; both can be used for overall washes; fine brushes can also be used for spotting. An alternative technique is to use an airbrush, which sprays very fine particles of color; although demanding in skill and expensive in equipment, this is probably the ideal method of applying graduated color that blends easily with the existing image. (GO TO PAGES 184-6, RETOUCHING.)

BODY COLOR Both toners and dyes penetrate the emulsion and are therefore transparent. Another type of color, which lies on top of the print and so conceals the image underneath, is pigment. Adding pigment or body color to a photograph requires all the skill of painting to achieve a delicate effect. Most colored pigments are oil-based.

TONER	EFFECT
SEPIA (SULPHIDE)	Yellow-brown to chocolate-brown
SELENIUM	Sepia to purple-red
IRON	Blue
COPPER	Red chalk to dark brown
NICKEL	Pink to magenta
VANADIUM CHLORIDE	Green
GOLD CHLORIDE	Steely blue-black with bromide paper Orange to bronze-black with bromide paper previously sepia-toned Purple-black with chlorobromide paper

Considerable variations are possible, by altering the strength of the solution and the length of toning, by controlling the amount of silver that is bleached, by varying the paper used and by combining methods.

RETOUCHING

KNIFE/SHAVING Use a scalpel with a curved blade, holding it at a shallow angle to the paper. Make regular strokes by flexing at the wrist rather than with the fingers.

KNIFE/POINTWORK To pick out spots from a print, a sharply pointed blade is best. Hold it at a steep angle, like a pen, and lift out a small area of emulsion with a slight flicking movement.

BRUSH WASH To apply dye or color to a large area, use a broad, rounded brush. Make full, overlapping strokes. Washing first with water can help avoid edge marks or other stains.

	COLOR		
	NEGATIVE	TRANSPARENCY	PRINT
KNIFE/SHAVING	Suitable. Now unfashionable technique. Marks often show.	Unsuitable	Unsuitable
KNIFE/POINTWORK	Suitable. Needs large negative. Possibility of permanent damage	Unsuitable	Unsuitable
WET SWAB	Suitable. Easier with large negative. Danger of unevenness	Suitable. Easier with a large negative. Some danger of unevenness	Possible. Judging color difficult
DRY SWAB	Unsuitable	Unsuitable	Unsuitable
BRUSH/WASH	Suitable. Easier with large negative	Possible	Possible. Judging color difficult.
BRUSH/DETAIL	Suitable	Unsuitable	Possible. Judging color difficult
AIRBRUSH/UNMASKED	Suitable. Difficulty depends on complexity of shading	Possible	Possible. Difficulty depends on complexity of shading
AIRBRUSH/MASKED	Suitable. Difficulty depends on complexity of the mask's outline	Possible	Possible. Difficulty depends on complexity of the mask's outline
CRAYON	Suitable	Unsuitable	Possible. Judging color difficult
PENCIL	Suitable	Unsuitable	Possible. For tonal corrections only

BRUSH DETAIL For detail, use small high quality (sable) brushes. Pick up a full amount of color, then draw most of it off against the lip of the dye bottle. Build up tone slowly with several pale applications.

AIRBRUSH For a precise area, use a mask cut from adhesive film or card, or a liquid mask painted on. Sweep the airbrush generously from side to side. Unmasked airbrushing needs more skill.

BLACK-AND-WHITE			
NEGATIVE	TRANSPARENCY	PRINT	LINE FILM MASK
Unsuitable	Possible	Suitable	Unsuitable
Unsuitable	Possible	Ideal	Unsuitable
Ideal. Work on non-emulsion side	Suitable	Ideal	Suitable
Unsuitable	Unsuitable	Unsuitable	Ideal
Suitable. Work on non-emulsion side	Suitable	Suitable	Suitable
Possible. Work first on non-emulsion side, then on emulsion	Suitable	Ideal	Suitable
Suitable. Work first on non-emulsion side, then on emulsion	Suitable	Ideal	Suitable
Suitable. Work first on non-emulsion side, then on emulsion	Suitable	Ideal	Suitable
Unsuitable	Suitable	Unsuitable	Possible
Unsuitable	Suitable	Unsuitable	Unsuitable

RETOUCHING/2

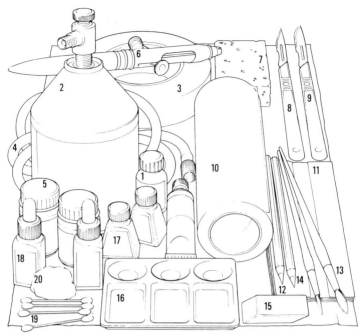

EQUIPMENT FOR AIRBRUSHING The airbrush, capable of producing fine, graduated tones of considerable delicacy and precision, is the ideal tool for retouching photographs. Suitable media include gouache, watercolor and special retouching dyes, all available in a variety of colors. Dyes also come in either matt or glossy finishes, to match the texture of prints.

1. Dry dyes for color retouching.
2. Compressed air supply.
3. Tape.
4. Airbrush hose.
5. Photo-opaque.
6. Airbrush.
7. Sponge.
8. Scalpel for pointwork.
9. Scalpel for shaving.
10. Masking film.
11. Absorbent paper.
12. Crayons and pencils.
13. Broad brush for washes.
14. Fine brush for details.
15. Eraser.
16. Mixing palette.
17. Dyes for black-and-white prints.
18. Color dyes.
19. Cotton buds.
20. Cotton swab.

The type of problem and the material you choose to work on determines which retouching tools you will need. The following techniques will cope with virtually all retouching needs.

1. Knife/shaving: Good for black-and-white prints, large black-and-white negatives.

2. Knife/pointwork: Good for black-and-white prints, large black-and-white negatives.

3. Wet swab: Good for black-and-white prints, color prints, black-and-white negatives, color negatives, transparencies.

4. Dry swab: Good for color prints.

5. Brush/wash: Good for black-and-white prints, color prints, black-and-white negatives, transparencies.

6. Brush/detail: Good for black-and-white prints, color prints, black-and-white negatives, transparencies.

7. Airbrush/unmasked: Good for black-and-white prints, color prints, black-and-white negatives, transparencies.

8. Airbrush/masked: Good for black-and-white prints, color prints, black-and-white negatives, transparencies.

9. Colored crayon: Good for color prints, black-and-white negatives.

10. Pencil: Good for black-and-white negatives.

INDEX

INDEX

chemicals, **150**
drying, **151**
loading film, **150**
processing, **151**
washing, **151**
diaphragm flare, **106**
diaphragm linkage, 145
diffused lighting, 44, 57; **56**
overcast weather, 82-3; **82,
83**
dirt, cleaning, 130; **130, 131**
enlarger maintenance, **174**
flare from, 124; **107**
disordered scenes, 60-1; **60, 61**
domestic lighting, 42, 45; **43**
doors, lightproofing, 172; **172**
double exposures, 63, 64, 81;
64, 65
faults, **113**
dropped cameras, 140; **140, 141**
drying cameras, 132-3; **132, 133**
dust, cameras and, 134; **134,
135**
on negatives, **162**
dyeing, prints, 182-3

E

eccentric compositions, 61
electrical storms, 46-7; **46, 47**
emergency repairs, **128**
enlargers, cleanliness, **162**
condensers, **165, 175**
installing, 174
maintenance, 174; **174-5**
in makeshift darkrooms,
170, 171
misaligned negatives, **163**
parts, **175**
shading and printing-in, 177,
178-9
shake, **165**
small apertures, 177
soft-focus, **165**
tilted lens, **165**
epoxy, **128**
events, ceremonial, 14-15; **14, 15**
crowds, 16-17
exposure, aerial photography, 50
bracketing, 43, 85; **81**
close-up photography, 116;
116-17
double, 63, 64, 81; **64, 65**
113

F

faults, **113**
faulty meters, 148-9; **148,
149**
fireworks, 49; **48**
flames, 49; **48, 49**
high contrast, 94, 121; **122**
interior shots, 43
key details, **122-3**
lightning, 47; **46, 47**
long, 84, 85
moonlight, 84, 85
multiple, 13; **113**
night-time, 81; **81**
overexposure, **105, 122**
polar light, 100; **100**
problems, 120-1; **120, 121,
122, 123**
snow scenes, 92-3; **92,
93**
star streaks, 85; **85**
tropical light, 96
underexposure, **11, 105,
106, 122**
eyes, portrait photography, 18-19
'red', **76**

fashion photography, settings,
-32 ·
fault-finder, 104-15
fees, models, 28-9
files, needle, **128**
fill-in flash, 95
fill-in lighting, 43; **45**
film, A type, 74; **105**
air freighting, 157
B type, 74; **42, 43, 74, 105**
clearing customs, 157-8
cold conditions, **137**
developing 150; **150-1**
fast, 10
fogging, 159, 172
hot conditions, 138; **139**
instant, 77
light leak, **114, 115**
mailing, 156-7
old stock, **104**
protection from X-rays, 157,
158-9
push-processing, 83
scratches, **114, 135, 151**
shipping, 156-9
tension marks, **114**

transparency, 94
tungsten, 74; **105**
unexposed, **106**
film advance lever, 142; **143**
filters, **42**
80B, 81; **80**
81 series, 82 93, 98
85 series, 98; **42**
flare, 124
fluorescent lighting, 68; **69**
fog, 89
graduated, 82, 95; **108**
magenta, 68; **69**
night-time simulation, 81; **80**
overcast weather, 82
photographing flames, 49
polarizing, 50, 56-7, 86; **86,
98, 108**
snow scenes, 93
soft-focus, 125
tungsten lighting, 74
UV, 50, 86
vapor lamps, 72; **72**
fingerprints, on negatives, **163**
fireworks, 49; **48**
fixer stains, **168-9**
flames, photographing, 49; **48,
49**
flare, 45, 124-5, 178; **124, 125,
126, 127**
diaphragm, **106**
filters, 124
from dirt or grease, 124;
107
from spray, **107**
flash, 76-7; **76, 77**
close-up photography, 116
enhancing movement, 13
fill-in, 95
freezing movement, 11
interior shots, 42
overcast weather, 83
portraits, **19**
studio, 19
fluorescent lighting, 68, 70, 78;
68, 69, 70, 71
focal length, combining images,
62-3; **62**
landscapes, 34
focal plane shutters, 144; **144**
focus faults, **111, 112**
focusing, in darkness, 81
lens checks, 147
focusing rings, dust in, **135**
focusing screen, cleaning, **130**

188

INDEX